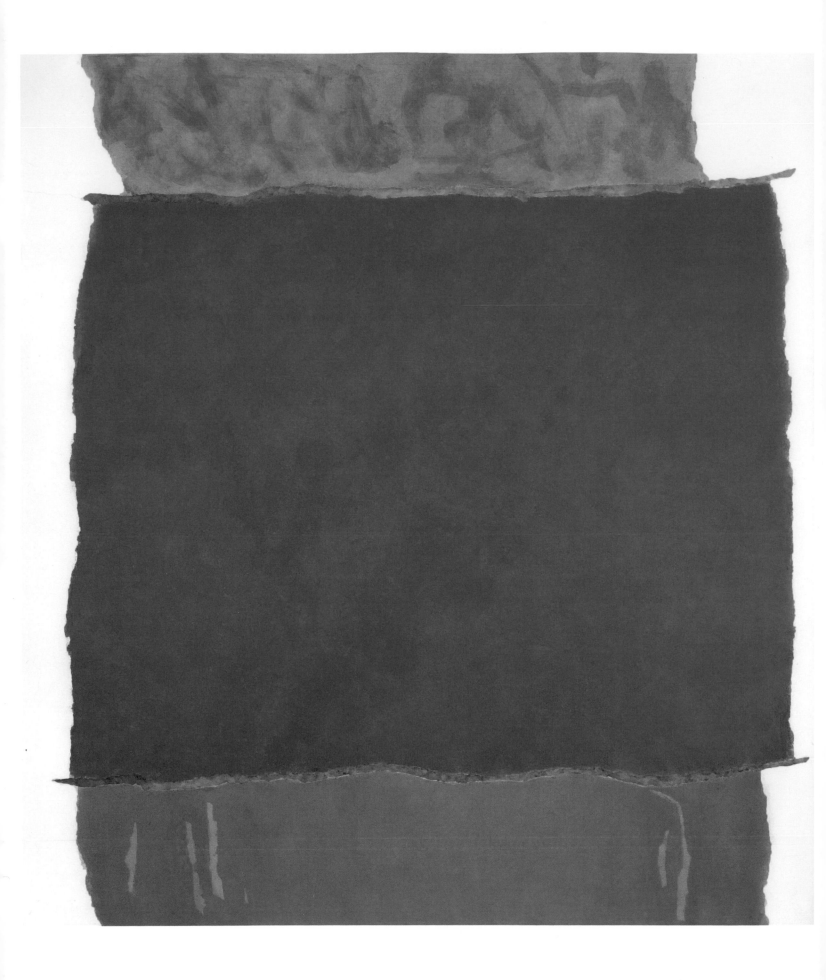

THEODOROS STAMOS
A COMMUNION WITH NATURE

May 13 through June 19, 2010

Essay by Robert S. Mattison

HOLLIS TAGGART GALLERIES

958 Madison Avenue, New York, New York 10021

This catalogue has been published on the occasion of the exhibition "Theodoros Stamos: A Communion with Nature," organized by Hollis Taggart Galleries, New York, and presented from May 13 to June 19, 2010.

ISBN: 978-0-9800745-5-0
Library of Congress Control Number: 2010922263

Front cover: Theodoros Stamos, *Delphic Shibboleth,* detail, 1959. Oil on canvas. (pl. 12)
Page 1: Thedorodos Stamos, circa 1940. Black and white photographic print, 24 x 19 cm. Courtesy of the Theodoros Stamos papers, 1922–2007, Archives of American Art, Smithsonian Institution.
Frontispiece: *Infinity Field (HH/TS/7),* 1978. Oil on canvas. (pl. 27)
Back cover: Theodoros Stamos, *Migration,* 1948. Oil on masonite. (pl. 8)

Hollis Taggart Galleries
958 Madison Avenue, New York, NY 10021
Tel 212 628 4000 Fax 212 570 5786
www.hollistaggart.com

Editing and publication coordination: Sarah Richardson
Design: Russell Hassell, New York
Printing: Capital Offset, Concord, New Hampshire
Photography of plates: Joshua Nefsky

TABLE OF CONTENTS

8 Foreword

10 Theodoros Stamos: A Communion with Nature
 by Robert S. Mattison

55 Plates

100 Chronology
 by R. Sarah Richardson

102 Checklist

104 Selected Public Colletions

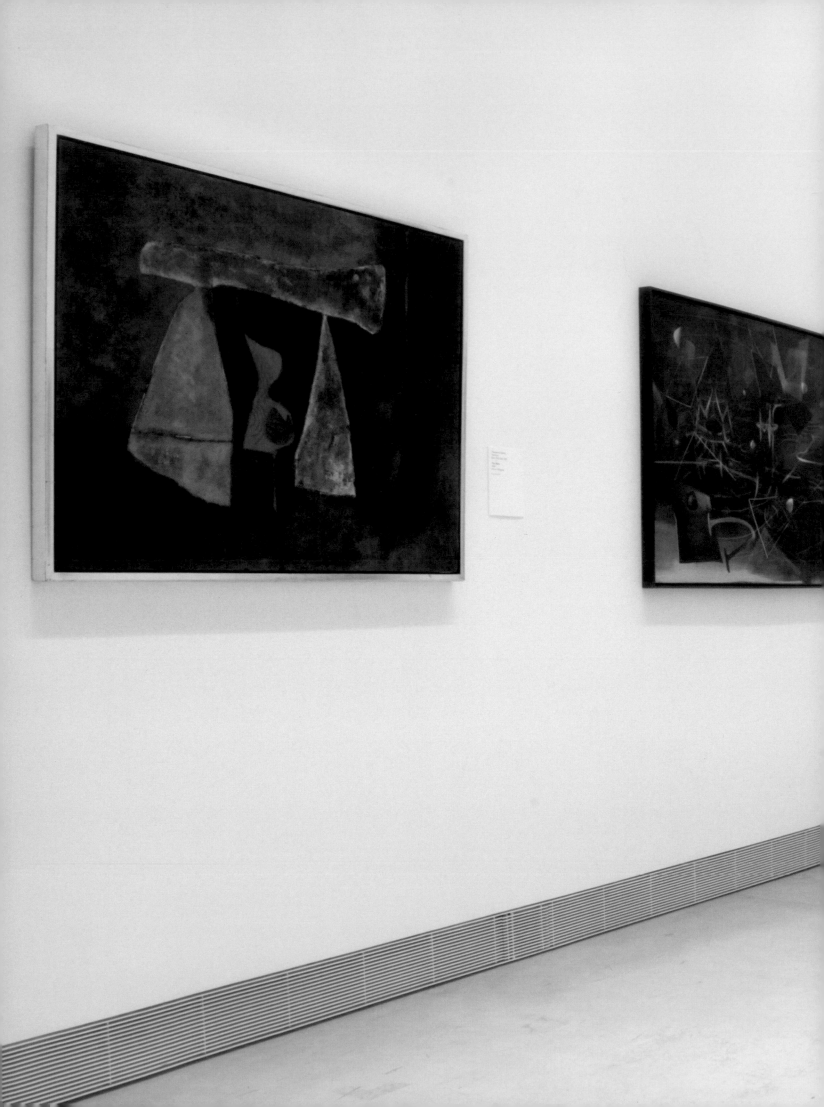

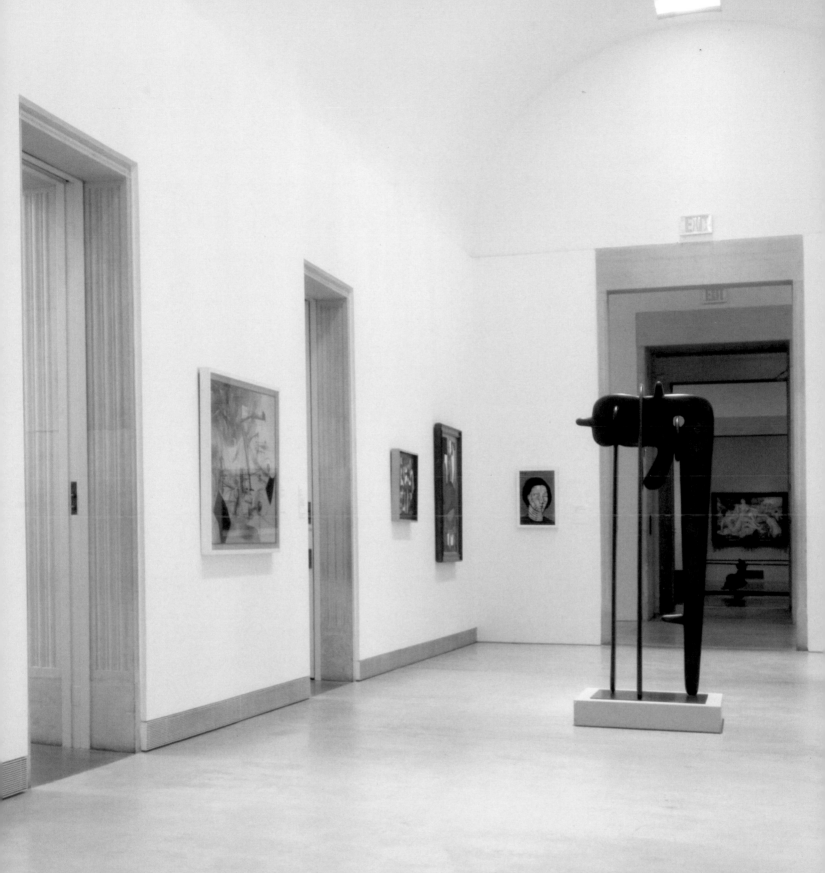

Philadelphia Museum of Art, permanent collection installation, fall 2009. At far left hangs Theodoros Stamos, *The Altar*, 1948. Oil on masonite, 36 x 48 inches. Philadelphia Museum of Art; Gift from the Savas private collection courtesy of Georgianna Stamatelos Savas honoring the artist's wishes

Right of Stamos hangs Roberto Matta, *To Escape the Absolute*, 1944 (2004-45-3). Isamu Noguchi's *Avatar*, 1948 (cast in bronze 1982; 2001-45-1), stands beyond. Opposite the Stamos is Jackson Pollock's *Male and Female*, *1942–43* (1974-232-1; not pictured).

FOREWORD

For the painter there exists a spiritual power which communicates life and meaning to material forms and that he must achieve this power before taking part in the elaboration of forms. Theodoros Stamos, "Why Nature in Art"

Abstract, symbolic, and imbued with much personal meaning, the paintings of Theodoros Stamos deeply resonate with rhythms borne from distillate visions of the natural world. The lyrical commingling with the firebrand, the poetic with the sensual, transform his own personal dialogue into the aesthetic realm of the spiritual and infinite.

We are pleased to present a retrospective spanning six decades of the artist's oeuvre, from the primordial forms of his early biomorphic paintings, which won him great acclaim as a young artist in his twenties, to the saturated color abstractions of the 1950s, and the later reductive and meditative Teahouse paintings, Sun Boxes, and Infinity Fields of the 1960s, 70s, and beyond. The diversity presented testifies to Stamos' prodigious talent, fierce individualism, and boundless intellect.

To take us through this retrospective journey, Robert Mattison, Marshall R. Metzgar Professor of Art History at Lafayette College and author of *Grace Hartigan: A Painter's World* and most recently, *Arshile Gorky: Works, Writings, Interviews*, has written an essay that elaborates on the large themes of nature, world cultures, ritual, myth, and color that informed every period of Stamos' important career. We are grateful to him for providing a new voice of scholarship and a fresh perspective to greater elucidate the life and art of the gifted artist. Understanding the humanity inherent in this artist and his creation allows us to appreciate his vision fully.

We extend our thanks to R. Sarah Richardson, Research Manager, who ably compiled a comprehensive and thorough artist's chronology to further enhance the biography and art of Stamos. Besides taking on the task of chronicling in great detail an abbreviated version of this artist's long and noteworthy career, she along with Stacey Epstein, Director of Modernism, provided invaluable advice and assistance regarding every aspect in the compilation and creation of this catalogue. Their consummate professionalism is heartily acknowledged.

Much gratitude is also expressed to the artist's sister and the executrix of his estate, Georgianna Stamatelos Savas. For the past year we have had the honor of assisting her in fulfilling her brother's wishes of gifting over 20 biomorphic works to important American museums. Through this extraordinary posthumous bequest, museum visitors will now see

Stamos' work take its rightful place among his contemporaries: Pollock, Gottlieb, Baziotes, and Newman, to name a few. The first of these gifts, *The Altar* (1948), illustrated on the preceding spread, can be seen in the Philadelphia Museum of Art surrounded by contemporaneous examples of early Abstract Expressionist masterpieces. Early in the gifting process, Michael Taylor, Muriel and Philip Berman Curator of Modern Art at the Philadelphia Museum of Art, offered much guidance and information on how to proceed with the requests. We are grateful to Mrs. Savas for her tireless dedication and extraordinary generosity in providing us with precious information and family stories; her book *Eyes on Stamos: A Sister's Memoir—A Brother's Wishes* is a resource of important research on the artist.

Exhibitions are often created as a result of fruitful collaborations with people who share the same desire in the further understanding of an artist's career and life. We therefore also wish to thank Eric and Paul Efstathiou of PTE Fine Arts for allowing us much generous access to valuable artist material in their possession, as well as scholarship and anecdotal information. Along with Mrs. Savas, PTE donated key documents to the Archives of American Art, and we thank Charles H. Duncan, Collection Specialist for the New York Region, for making this process a smooth one.

Those who have graciously loaned works to the exhibition, we thank: Georgianna Stamatelos Savas, Nestor and Kathy Savas, Stephen and Mary Craven, Professor Athena Lazarides Demetrios, and John and Denise Ward.

We are most appreciative of the assistance offered by the following: Cristin O'Keefe Aptowicz, Artists Rights Society; Wendy Hurlock Baker and Joy Weiner, Archives of American Art; Frank Bara; Jennifer Belt and Michael Slade, Art Resource; Stephen Borkowski; Pamela Caserta, Walker Art Center; Diran Deckmejian; James DiMartino; Andrew Dintenfass; Morfy Gikas; Jennifer Ginsberg, Philadelphia Museum of Art; Kiowa Hammons, Whitney Museum of American Art; Marvin Hayes; Michael Preble; Melita Schuessler; and Trish Waters, Phillips Collection.

Our team at Hollis Taggart Galleries continues to inspire and make possible all of our efforts; we are pleased to acknowledge Debra Pesci, Associate Director; Martin Friedrichs, Assistant Manager; Reid Ballard, Registrar; Kara Spellman, Director of Imaging & Web; assistants Letty Holton and Ethan Seidel; and intern Lauren Glaves-Barrett. And as always, this publication was skillfully designed by Russell Hassell and printed by Jay Stewart and Ken Ekkens of Capital Offset.

Hollis Taggart, *President*
Vivian Bullaudy, *Director*

The work of Theodoros Stamos, subtle and sensuous as it is, reveals an attitude toward nature that is closer to true communion. His ideographs capture the moment of totemic affinity with the rock and the mushroom, the crayfish and the seaweed. He redefined the pastoral experience as one of participation with the inner life of the natural phenomenon. One might say that instead of going into the rock, he comes out of it. In this Stamos is on the same fundamental ground as the primitive artist, who never portrayed the phenomenon as an object of romance and sentiment but always as an expression of the original noumenistic [sic] mystery in which rock and man are equal.[1]

In 1947, Barnett Newman wrote this text as an introduction to Theodoros Stamos' exhibition at the Betty Parsons Gallery. Stamos was then only twenty-five years old. Newman and Mark Rothko, both of whom were in their forties, discovered Stamos' work in his first one-person exhibition of 1943 at the Wakefield Gallery and were so taken with his paintings that Newman also included them in his groundbreaking exhibition of 1947, "The Ideographic Picture." By the time that exhibition opened, Stamos was already well known within avant-garde circles, and his patron Edward Root had given *Sounds In the Rock* (1946, fig. 1) to The Museum of Modern Art, his first museum acquisition.[2] Newman's prescience in discussing Stamos' work is notable; the internalization of nature as both an entity and a symbol was essential to Stamos' remarkable early works, and it remained a touchstone throughout his long career. For Stamos, the dynamism, morphology, and elemental rhythms of nature provided essential inspiration, and his works embody the flow and pulse of the natural world. The artist identified so closely with the vital forces of nature that they became united in his mind with the process of artistic creation.

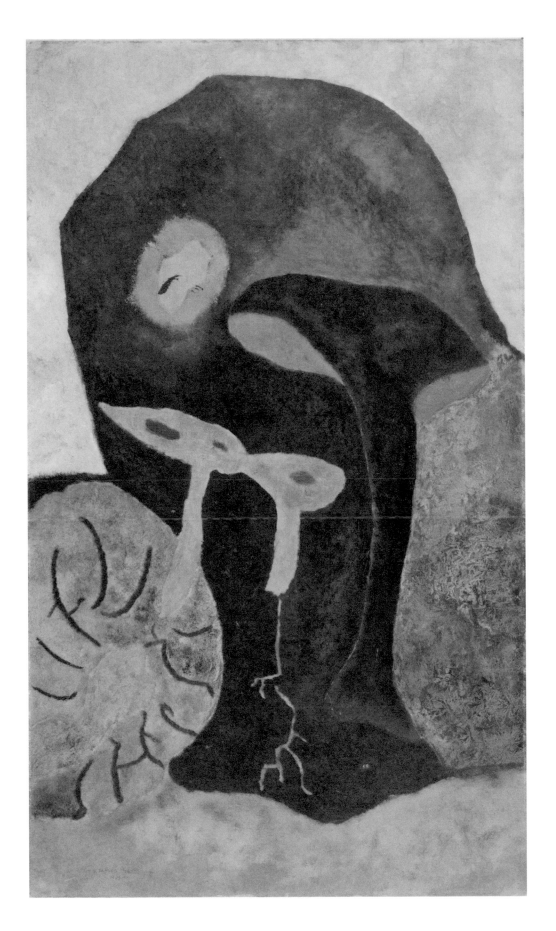

FIG 1
Theodoros Stamos, *Sounds in the Rock*, 1946. Oil on composition board, 48⅛ x 28⅜ inches. The Museum of Modern Art, New York; Gift of Edward W. Root. The Museum of Modern Art/Licensed by SCALA/Art Resource, New York, NY

Stamos' paintings, which figure prominently in the development of American modern art and express some of the profound ideas of their age demand greater critical attention because of their high aesthetic and intellectual quality.[3]

Stamos was an essential figure in the creation of Abstract Expressionism and, for instance, was given a prominent position in Nina Leen's famous 1951 *Life* magazine photograph of the group which was dubbed the "Irascibles" (fig. 2).[4] Nevertheless, his insights into the spirit of the natural world differentiated him from the other artists who turned more completely toward psychological exploration. In addition, the other Abstract Expressionists saw nature as an arena for conflict and survival of the fittest. By contrast, nature symbolized for Stamos transformation and continuity; it was for him a central life force that lent his works a subtle and gentle air differentiating them from the more strident canvases of his contemporaries.

The major event of Stamos' youth, as for all of his generation, was World War II. The world's first global war left nearly three hundred thousand Americans, over three million Germans, and six million Russians lying dead in the field of battle. As an example of the scale of warfare unprecedented in human history, between 1939 and 1945 the Allies dropped 3.5 million

Dove's work communicated a lyrical vision of nature that Stamos, who studied many of the same intellectual and artistic sources, would amplify in the next generation.

tons of bombs on Europe. As would be expected, most of the Abstract Expressionist artists reacted to the war with paintings that evince terror and desperation. Stamos' work differs. While his paintings are often somber in coloration, they suggest the regenerative forces of nature rather than destruction. By and large, Stamos' biomorphic shapes interact in a gentle manner. They often appear to be nurtured in womb-like aquatic environments. This tendency does not signal Stamos hiding away from the war, but rather he was looking beyond it to the life-enhancing character of nature that would prevail despite the tragic years of the 1940s.

The story of Stamos' origins is one of innate ability and self-education. Born Theodoros Stamatelos in New York City on December 31 of 1922, Stamos was the fourth of six children of Greek immigrant parents; his mother Stamata was from Sparta and his father Theodoros from Lefkada. The family lived on the Lower East Side of New York, and Stamos' father, who had been a fisherman in Greece, ran a small hat-cleaning and shoe-shining shop. In addition to instilling a strong work ethic, Stamos' parents taught him to be stoic and not to show pain, thus earning the nickname "Sparti" from his mother. Throughout his life, the gruff exterior that Stamos often presented to the outside world contrasted with the sensitivity displayed in his art and in his relationships with his closest friends. While the hard-working family had little time for the arts, Stamos was raised with Greek folk tales that often involved the mysterious forces of nature.

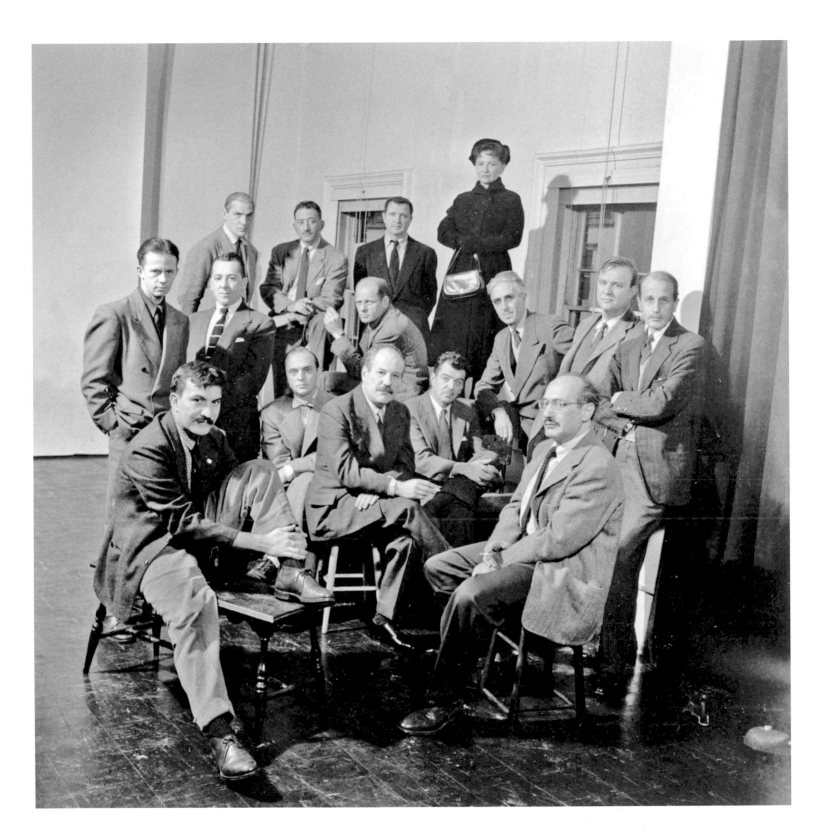

FIG 2

The "Irascibles," 1950: Seated left to right, first row: Theodoros Stamos, Barnett Newman, Mark Rothko. Seated left to right, second row: Jimmy Ernst, James Brooks. Standing left to right, third row: Richard Pousette-Dart, William Baziotes, Jackson Pollock, Clyfford Still, Robert Motherwell, Bradley Walker Tomlin. Standing left to right, fourth row: Willem de Kooning, Adolph Gottlieb, Ad Reinhardt, Hedda Sterne. Photo by Nina Leen/Time Life Pictures/Getty Images

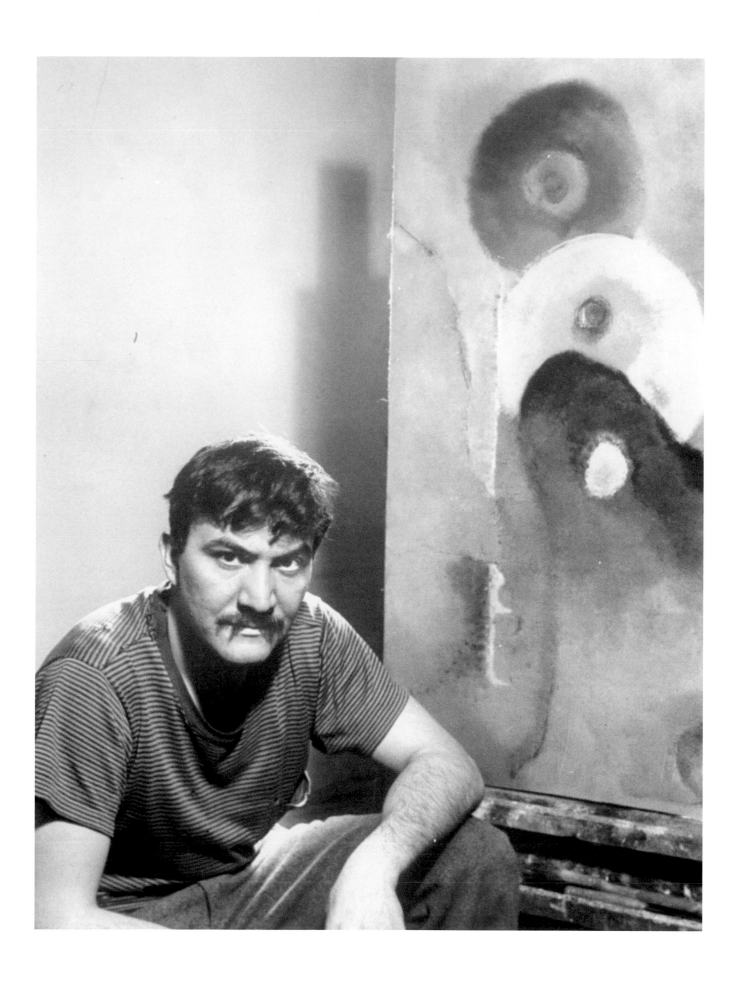

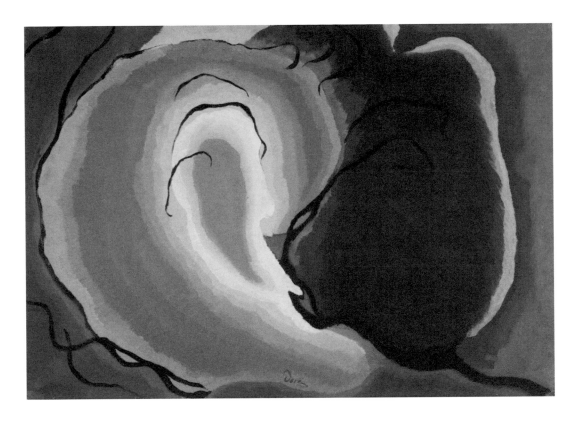

FIG 3
Theodoros Stamos, circa 1950.
Photo by Alfred Eisenstadt/Time
& Life Pictures/Getty Images

FIG 4
Arthur Dove, *Tree Composition*, 1937.
Oil on canvas, 15¼ x 21 inches.
Munson-Williams-Proctor Arts
Institute, Utica, New York; Edward
W. Root Bequest, 57.136. Munson-
Williams-Proctor Arts Institute/
Art Resource, New York, NY.
© The Estate of Arthur G. Dove

Among the artist's earliest memories was journeying with his father to the seashore of Long Island to collect seasonal plants and flowers to sell in the city. At age eight, Stamos ruptured his spleen and during his convalescence began to draw. The quality of his youthful drawings earned him a place at Peter Stuyvesant High School and a scholarship to evening classes at the American Artists School. At the art school, Stamos first worked in sculptural carving. The reductive techniques through which he sought an essence buried within the stone may have influenced Stamos' later tendency to scrape down the surfaces of his paintings in order to discover the inner life of the forms depicted. At the artists' school, Joseph Solman, who was a member of the artists' group The Ten, became a mentor to Stamos and advised him to go to Alfred Stieglitz's An American Place gallery and to pay particular attention to the work of Arthur Dove. Dove, who was largely ignored by the other Abstract Expressionists, became an inspiration for Stamos (fig. 3). Decades later, Stamos continued to recommend the careful study of Dove's works, like *Tree Composition* (1937, fig. 4), to his students.[5] Like Dove, Stamos transposed but did not entirely eliminate his landscape impressions, and his living organic forms by analogy constantly evoked nature. Employing fragments of everyday reality in a mode that motivated Stamos, Dove evolved a tender poetry distinguished by its simplicity and grace. Based on both science and mysticism, Dove's work communicated a lyrical vision of nature that Stamos, who studied many of the same intellectual and artistic sources, would amplify in the next generation.[6]

While Dove provided a way to understand nature both as science and symbolic structure, Milton Avery presented Stamos with clues as to working methods. Joseph Solman knew

Avery through his participation in The Ten, an art group also including Rothko and Adolph Gottlieb that was centered around Avery.[7] Stamos first studied Avery's works at Valentine Dudensing Gallery and later met Avery.[8] With their flattened space and simplified forms, Avery's works like *Church by the Sea* (1939, fig. 5) stimulated Stamos' own early seaside paintings. Using Henri Matisse's oeuvre as an example, Avery drew directly with the brush to communicate immediacy of the artistic expression, a method adopted by Stamos. First acquired through Avery, Stamos' interest in Matisse grew profoundly throughout his entire career and blossomed most completely in the artist's Infinity Field paintings (1970–1993). In the meantime, Avery's thin washes of pigment and chalky tones further communicated to Stamos the amorphous character of experience. A comparison to Stamos' *Untitled (Seascape)* of 1940 (fig. 6), however, highlights Stamos' differing vision of a more remote and less civilized nature, one that depends less on narrative incident and more on the primal elements of the natural world: earth, air, and water. Stamos' *Coney Island* (1945, pl. 3) features a recognizable location, but the locale has been stripped of genre incidents. Instead, Stamos has universalized the setting by scattering across the thinly brushed surface a variety of organic elements. Beach detritus is below the horizon line, while above it a schematic rollercoaster appears. The undulating pattern of all the elements suggests connecting links between nature and man-

It was Darwin's ideas about the restorative powers of nature that interested Stamos and differentiated him from the Surrealists and more tumultuous works of the other Abstract Expressionists.

made objects, all united by organic liveliness. The viewpoint expressed in these paintings was dependent not only on Stamos' discovery of such painters as Dove and Avery but also on his broad understanding of the science, history, and culture of the period.

By 1939, the year he left Peter Stuyvesant High School, Stamos had already become a voracious reader. He had begun to frequent book shops, collecting older volumes and establishing an extensive library.[9] Stamos was a remarkable autodidact who absorbed key ideas of his age. His personal library included such titles as *Grey's Botanical Textbook*, William Buckland's *Geology and Mineralogy Considered with Reference to Natural Theology*, Douglas Campbell's *Seaside Studies of Natural History*, and Charles Darwin's *The Power of Movement in Plants*.[10]

Stamos' interest in geological forms in his art was closely tied to the scientific discoveries of his age. The 1930s was an important growth period for the natural sciences. Particularly significant was the interaction between geology and biology, which entailed the study of prehistoric organisms, their evolution, and their interactions with their environments. Magazines and popular scientific journals hailed new discoveries. Systematic fossil collection was particularly strong in North America, providing new information about the earliest evolution of

FIG 5
Milton Avery, *Church by the
Sea*, 1939. Gouache on paper,
21⁹⁄₁₆ x 29¹³⁄₁₆ inches. Wadsworth
Atheneum Museum of Art,
Hartford; Gift of CIGNA. 2005.3.1.
Wadsworth Atheneum Museum
of Art/Art Resource, New York, NY.
© 2010 Milton Avery Trust/Artists
Rights Society (ARS), New York, NY

FIG 6
Theodoros Stamos, *Untitled
(Seascape),* 1940. Colored
charcoal and watercolor on paper,
9 x 14 inches. Collection of
Georgianna Stamatelos Savas

FIG 7

Andre Masson, *Battle of Fishes*, 1926. Sand, gesso, oil, pencil and charcoal on canvas, 14¼ x 28¾ inches. Museum of Modern Art, New York, NY. © 2010 Artists Rights Society (ARS), New York/ADAGP, Paris

dinosaurs, fish, animals, and birds. In these collections, rocks were split open to reveal their geological origins and to show fossilized remnants of early life forms. During the 1940s, Stamos frequently spoke about "painting from inside the rock" to express his imaginative identification with such discoveries. These geological unearthings, featured in such magazines as *National Geographic*, sparked Stamos' imagination and encouraged him to create an art that would reach, poetically, into the deepest recesses of the history of life.

Motivated by his interest in geology and biology, Stamos became fascinated by the history of evolution as it developed during the nineteenth century, especially the work of Charles Darwin. Cultural interest in Darwin's ideas was particularly strong during World War II because the popular interpretation of Darwin's "survival of the fittest" seemed to correspond to the dominance of warfare in the modern age.[11] Such violent scenarios were played out in paintings like André Masson's *Battle of Fishes* (1926, fig. 7). In fact, Darwin's ideas of evolution centered as often on accommodation and acclimation of species as they did on conflict. It was Darwin's ideas about the restorative powers of nature that interested Stamos and differentiated him from the Surrealists and more tumultuous works of the other Abstract Expressionists. Darwin's *The Power of Movement in Plants* describes various types of movements like

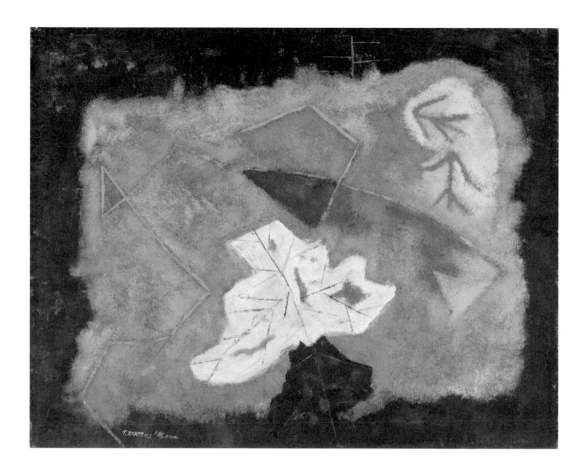

FIG 8
Theodoros Stamos, *Movement of the Plants*, 1946. Oil on masonite, 16 x 20 inches. Munson-Williams-Proctor Arts Institute, Utica, New York; Edward W. Root Bequest. 57.251. Munson-Williams-Proctor Arts Institute/Art Resource, New York, NY

heliotropism and geotropism, reactions to the sun and earth that allow plants to survive and grow.[12] The notion that dynamic movement and metamorphosis marked successful evolution since the beginnings of the earth attracted Stamos. It provided a promise of continuity during the chaotic period of the 1940s.

In 1945, Stamos named a painting *Movement of the Plants* (fig. 8) in homage to Darwin. The work exhibits an earthy core set within a dark space. The irregular white and yellow forms contain geometric patterns that can be read as veins of plants but may also be seen as directional arrows indicating the movements and interactions of these organic forms. A further pattern of meandering lines running throughout the painting indicates larger patterns of activity. Stamos' *The First Cylcops, #1* (1947, fig. 9), *Earliest Springtime* (1948, fig. 10), and *Untitled (Circular Motion)* (ca. 1945–49, fig. 11) embody such forces of growth. In *Untitled (Circular Motion)*, a thin stream of blue pigment travels an uncertain course at the lower edge of the painting. Suddenly, the ribbon of pigment rises vertically through the dark ground and explodes into a radiating energy patterns and lights the darkness that surrounds it. Stamos' works clearly represent a poetic response to Darwin. In them Darwin's science has been translated into an overall visualization of life force with all of its mystery. Likewise, *Chrysalis I* (1947, fig. 12)

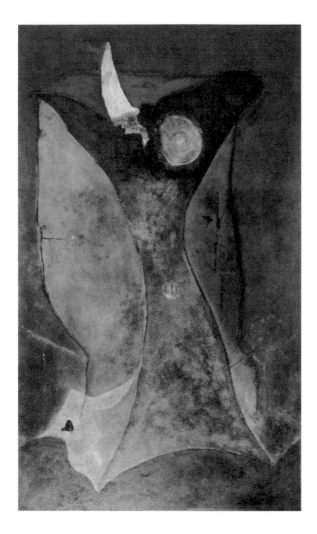

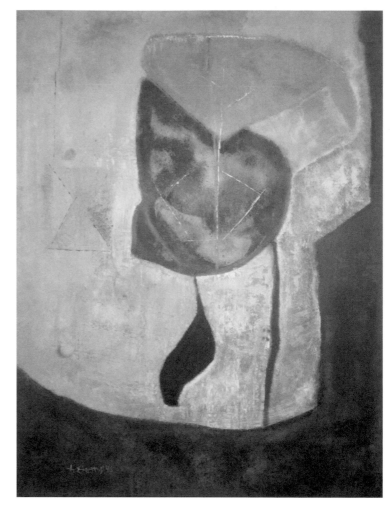

focuses on transmutation in nature. A chrysalis is the nympha or pupal stage of butterflies. The curving shape within Stamos' painting suggests the silken pod woven by the caterpillar, and the golden area represents the metallic gold coloration of the pupa from which the term chrysalis is derived. Green angular shapes connote the leaves of the tree onto which the pod is attached. The painting's thin agitated brushwork suggests the pod about to be broken open by the pumping of the butterfly's wings. Like the process of pupa becoming butterfly, meta-morphosis is one of Stamos' overarching themes.

In his insistence on the enigmatic character of life, Stamos found inspiration in the nineteenth-century concept of "natural theology" as exemplified by such authors as William Buckland, whose book on science and philosophy was important to Stamos. During the nine-teenth century the developing field of evolution was divided. On one hand, Darwin and his colleagues charted the natural world looking solely for scientific explanations for the changes in species. Another group of scientists, including figures like Buckland, studied the same phe-nomena and concluded that only God as a divine programmer could have designed such an

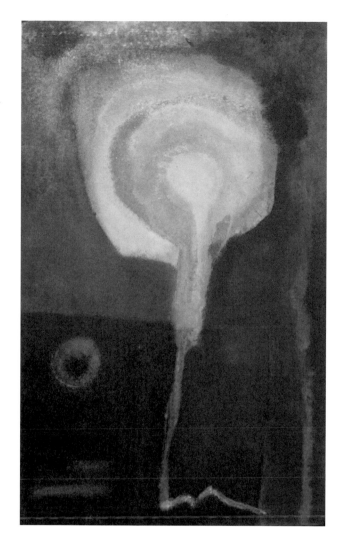

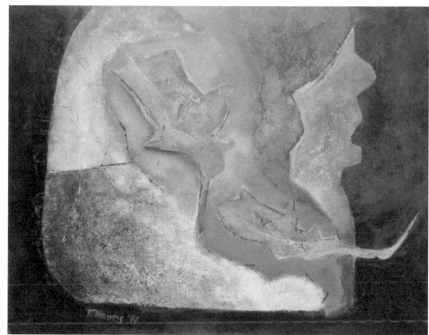

intricate system; they called this belief "natural theology."[13] While Stamos did not practice any traditional religion, he found this second group of scientists important because they investigated the natural world while maintaining its essential mystery. For Stamos, life contained truths that transcended rational discourse, and the ambiguity underlying the metamorphosis of organisms was an essential feature in his understanding of the world. The contrast between dark or radiant colors in his works, his elusive presentation of space, and depiction of forms that are open to a variety of interpretations all maintain this essential mystery.

Many of Stamos' most important paintings during the 1940s explore the origins of life in an undersea environment. In addition to the general notion of life beginning in the sea, study of the ocean and its evolutionary role was an important area of scientific study during the 1940s. Due to World War II, there was a new emphasis on mapping the ocean floor. While the impetus was preparation for submarine warfare, the process resulted in a wealth of new scientific information. Continental margins and distinctive rock units in the sea were better understood. In popular magazines like *Life*, *Look*, and *Scientific American*, these discoveries

FIG 11
Theodoros Stamos, *Untitled (Circular Motion),* 1946–1949. Oil on masonite, 40½ x 24⅝ inches. Collection of Georgianna Stamatelos Savas

FIG 12
Theodoros Stamos, *Chrysalis I*, 1947. Oil on masonite, 23⅞ x 30 inches. Collection of Georgianna Stamatelos Savas

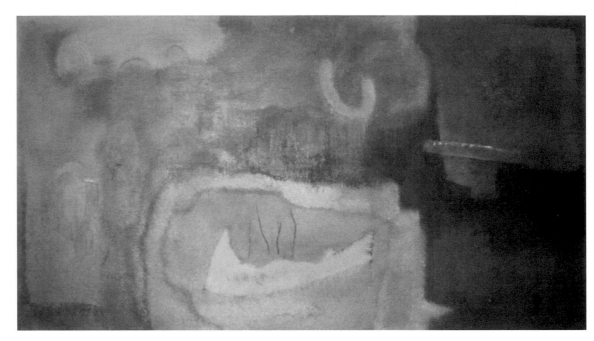

were illustrated through colorful drawings and hailed as providing key insights into the origins of the world and of life on Earth. Photographs and scientific drawings of fossils brought up from the sea floor have a striking resemblance to the imaginative organisms that Stamos created in his painting of the 1940s. Stamos himself avidly collected items from the shore during frequent summer visits. Thomas Hess, critic and editor of *Art News* magazine, noted in an early visit to his studio that the "world of echinoids, sea anemones, crabs and fossils which Stamos has claimed . . . exist as objects not only in the pictures but also in a bookcase in Stamos' studio." (fig. 13)[14]

Paintings such as *The Vale of Sparta* (1949, fig. 14) and *Nautical Warrior* (1946–47, pl. 4) suggest primordial life forms. *Nautical Warrior* features a dark form that is part cellular but also has developed the distinct pattern of tentacles or a spinal cord. The creature might be compared to an illustration of squid from Darwin's voyage to the Galapagos (fig. 15). In Stamos' painting, the squid-like creature swims amid a rich aquatic environment created with mixtures of blue, green, and umber pigment. The creature moves toward a vegetal form to the left. Stamos' depiction might be contrasted with André Masson's *Battle of Fishes* (1926, see fig. 7). Stamos became interested in the exiled Surrealist artists during the 1940s. He saw Masson's work at Buchholz Gallery, met André Breton and Max Ernst, and read the major Surrealist

FIG 15
Two types of squid. From
*The Voyage of the Beagle:
Charles Darwin's Journal
of Researches.* Snark/Art
Resource, New York, NY

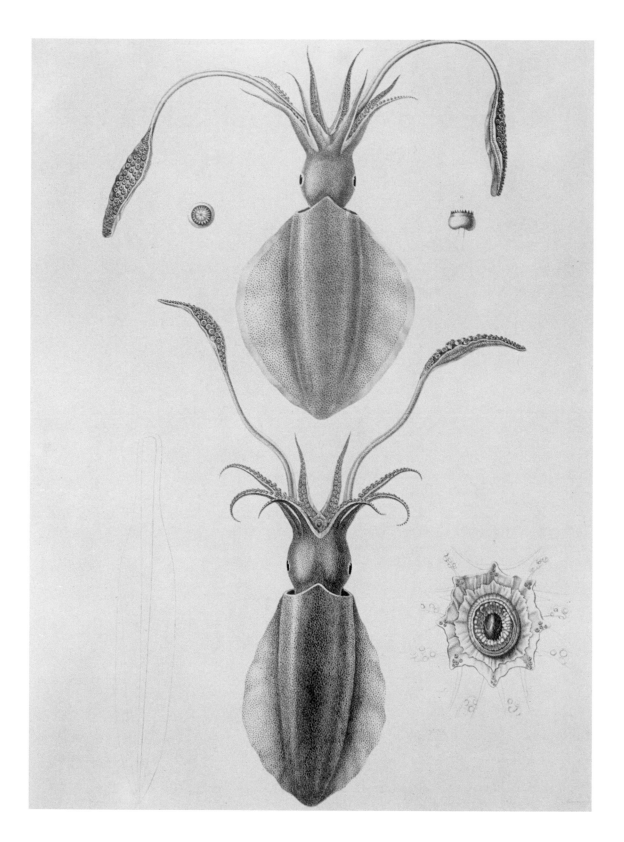

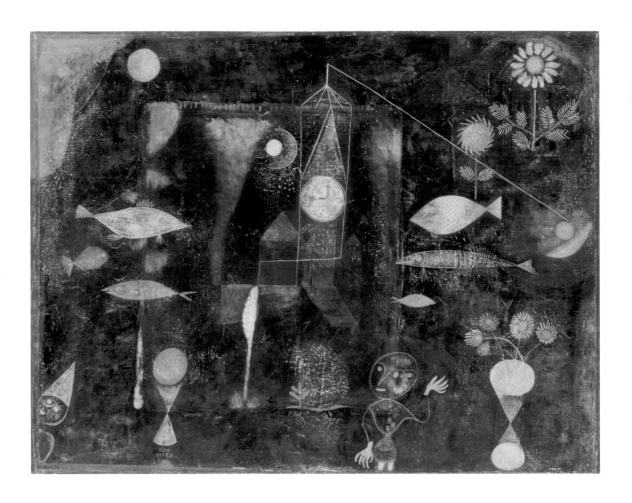

publications of the period. While Stamos' primal and archetypal scene parallels Masson's, his work is less violent, and the execution of Stamos' works is also far more subtle. Stamos knew of Surrealist automatism and was particularly interested in Ernst's methods of frottage. Stamos' own painting techniques were equally experimental but proceeded in a slow manner that allowed the rich and evocative character of his environments to emerge. Most of his works during the 1940s were executed on masonite supports. While the original choice of this material was due to the fact that it was less expensive than canvas, the masonite boards provided a firm surface on which the artist could manipulate his pigment and the warm tonality of the boards enriched the colors. In the case of *Nautical Warrior*, Stamos has used rags to wipe down the pigment to create the aquatic depth on the right side, while he has used a sponge to stipple the surface on the left making this area appear like sea moss. The use of inventive painterly techniques is a leitmotif of Stamos' career.

Another lodestar for Stamos in the 1940s was the art of Paul Klee. During the early forties, Stamos worked at a frame shop to support himself while painting at night. He recalled framing dozens of Klee works and becoming interested in his art.[15] *Fish Magic* (1925, fig. 16) was created after Klee visited the famous aquarium in Naples, Italy, and became so fascinated by the variety of fish that he engaged in a study of their different species. Klee's approach to the same theme as Stamos highlights connections and differences between the two artists.

For Stamos, life contained truths that transcended rational discourse, and the ambiguity underlying the metamorphosis of organisms was an essential feature in his understanding of the world.

Stamos was influenced by the simplification of Klee's forms and the Swiss artist's representation of elements in nature as two-dimensional signs. Yet Klee's fish are recognizable and playful. They fit comfortably into a contemporary experience. Stamos, however, creates hybrid forms that suggest primitive living presences but are remote from our contemporary experiences so that they encourage us to enter a primordial world created by the artist. In this regard, Stamos' approach resembles that of Arshile Gorky.

Like Stamos, Gorky was deeply inspired by the natural world. Gorky used the environment as a source for his imaginative creations, which did not mimic nature but revealed its underlying truths. When Stamos met him in 1941, Gorky had just returned from a trip across the country, which marked his first time outside of New York City in many years. On this trip, Gorky was inspired by the grandeur of the American west. His painting *Mojave* (1941–2, fig. 17) suggests the colors, mountains, dried trees, and bone fragments found in the Mojave Desert. Gorky's imaginings of a primal nature paralleled discoveries that Stamos was then making in his art (fig. 18). In 1958, Stamos wrote one of the most telling tributes to Gorky, one that might stand for Stamos' own worldview:

One vanguard painter who followed what is an original course for an occidental is the late Arshile Gorky, who threw his head in a grass patch and came out dazzled by the effects of fireflies, grasshoppers, dew and ants. As he sought the clear plateau of identification, his canvases became theaters for the unbounded color transparencies and iridescent shots and rhythm. I cannot think of a better example of an American artist's continuing growth in search and realization of nature.[16]

As further inspiration for his imaginative recreations of a primordial world, Stamos visited the Museum of Natural History in New York so frequently that his sister Georgianna Savas remembers it as a second home for him.[17] The arrangement of the museum during the 1940s mixed displays of natural elements like gems and minerals with dinosaur reconstructions and tribal cultures. Such a synthesis of primitive cultures, prehistoric creatures, and natural forms came from the cabinets of curiosities of the seventeenth century and a nineteenth-century view of evolution, one with which Stamos was already sympathetic.[18] The displays in the museum used dramatic background paintings and lighting effects to highlight the oddity of the objects. In this way, they encouraged the mysterious view of primordial nature found in Stamos' works as well as those of a number of other Abstract Expressionist artists. One of the sensations of the museum was the Milstein Hall of Ocean Life, which dates to the 1930s. The bi level room featured a diorama of the "Sperm Whale and Giant Squid," a mixture of art and science since an actual meeting of these two creatures at over one-half mile ocean depth has never been recorded. Hanging dramatically from the ceiling, then as today, was the 94-foot model of a blue whale. Stamos' painting *Ancestral Construction* (1946, fig. 19) depicts a large

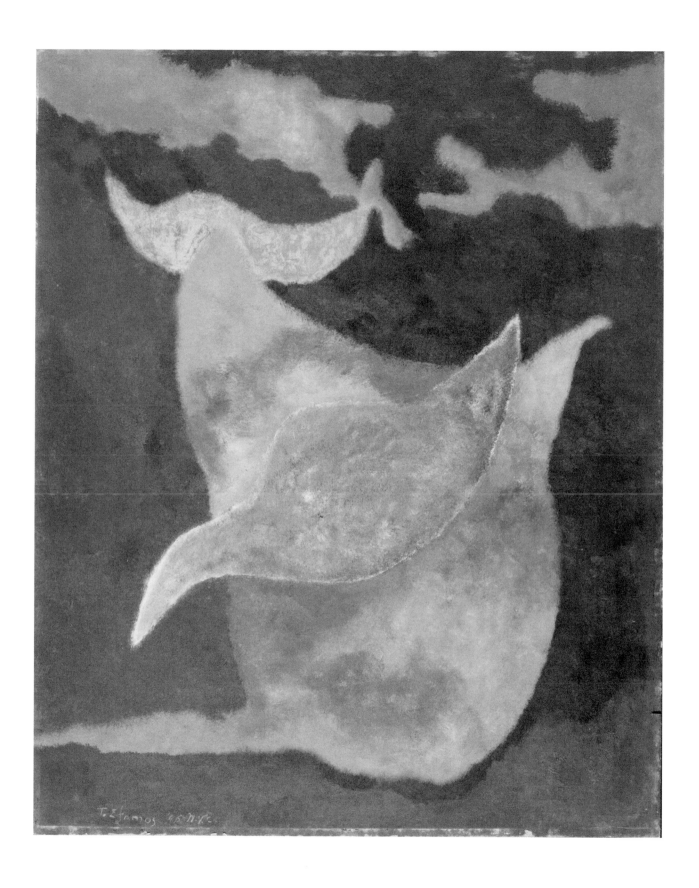

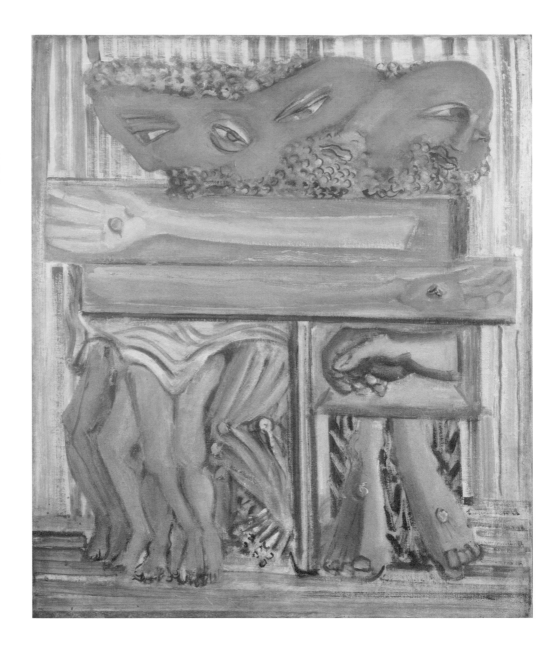

sea creature floating against a dark ground that recalls that display. As stimulation for his paintings that combined science and imagination, Stamos also must have visited the New York Aquarium. Founded in 1896 and housed at Castle Garden in Battery Park until 1941 when it was moved to the Bronx Zoo, it was the first and most famous aquarium in America home to several hundred aquatic specimens.

In Stamos' art, natural history and mythology were conjoined to form a connection between natural forces and the human interpretation of nature. Stamos later noted that "things are created by the mind rather than the mind perceives existing things."[19] During his childhood, Stamos was told mythological tales. He was well aware of the Greek tradition of classical mythology that influenced such artists as Adolph Gottlieb, Rothko, and Newman, but he was far more interested in folk myths that dealt with basic forces in the natural world. These folk tales led

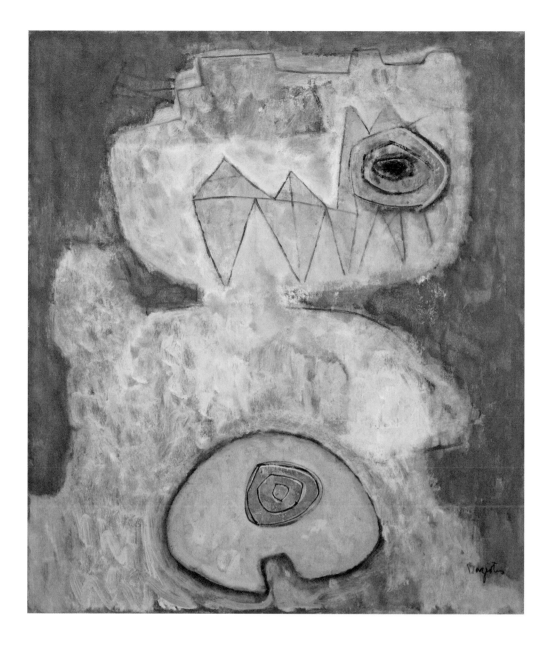

FIG 21
William Baziotes, *Dwarf*, 1947.
Oil on canvas, 42 x 36⅛ inches.
The Museum of Modern Art,
New York; A. Conger Goodyear
Fund. (229.1947). Digital Image
© The Museum of Modern
Art/Licensed by SCALA/Art
Resource, New York, NY

Stamos to investigate the history of mythology. He has identified Sir James Frazer's *The Golden Bough* originally published in 1890, a book widely read by the Abstract Expressionists, as very important for him.[20] While Frazer's book is in theory a study of the succession of an ancient priesthood, it is actually a wide-ranging study of myths and rites in both the western and non-western world, and it was considered a virtual encyclopedia of tribal beliefs. One of Frazer's primary themes is the savagery of so-called primitive societies, and understandably, it was this theme that during World War II occupied most of the Abstract Expressionist artists. The subject of primitive brutality can be found in works such as Gottlieb's fierce pictographs on the theme of the Oedipus myth and in Rothko's *Crucifix* (1941–2, fig 20) where hands nailed to boards, dangling feet, and masked faces crowd the surface. Such cruelty is also present in works by William Baziotes like *Dwarf* (1947, fig. 21) where the creature, part horrifying and part pathetic, was

FIG 22

Theodoros Stamos, *Shofar in the Stone*, 1946. Oil on masonite, 39⅝ x 24½ inches. Mint Museum of Art, Charlotte, North Carolina. Gift from the Savas Private Collection, courtesy of Georgianna Stamatelos Savas, honoring the artist's wishes, 2009.75

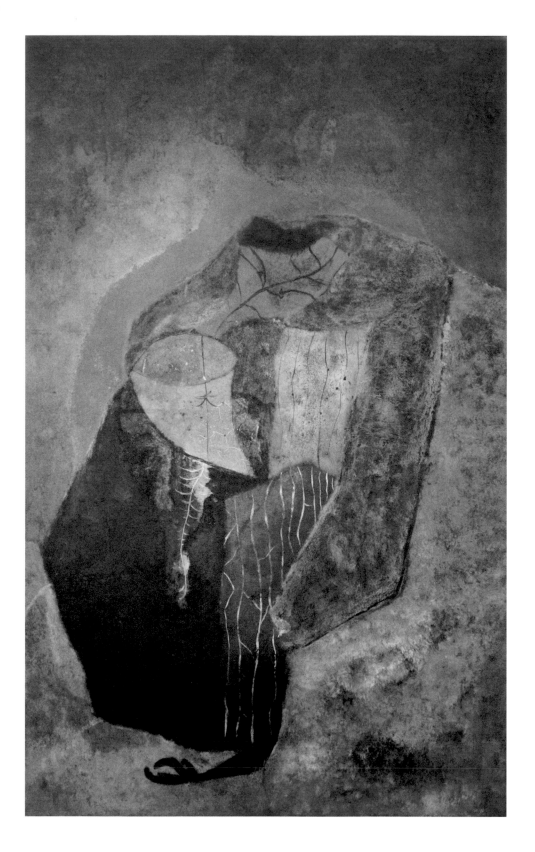

derived from the artist's memory of a crocodile eye and an image of a World War I amputee. In contrast to these brutal depictions, Stamos turned to the sections of Frazer that discussed the ability of myth to integrate humans into the natural world, one that expressed belief in the benign character of natural forces. Such ideas are found in Frazer's discussion of "Sympathetic Magic" and "The External Soul in Inanimate Things and Plants."[21]

Further, the notion that human psychology paralleled evolutionary tendencies was proposed during this era by a range of intellectuals, most importantly Karl Jung who wrote, "Just as the human body connects us with mammals and displays numerous relics of earlier evolutionary stages going back even to the reptilian age, so the human psyche is likewise a product of evolution which, when followed up to its origins, shows countless archaic traits."[22] So, when Stamos depicts geology and prehistoric life forms, he is delving simultaneously into the psychological origins of humankind.

The angular shapes of Stamos' painting *Shofar in the Stone* (1946, fig. 22) allude to the profile of a specimen rock that has been split. The rich layers of geological history within it are communicated by Stamos' variety of linear patterns, colors, and surface textures. Several areas feature lines growing from a central spine so as to connote fossils. Amid these forms is a blue

In Stamos' art, natural history and mythology were conjoined to form a connection between natural forces and the human interpretation of nature.

cone that resembles a shofar, a ram's horn that was used according to the Old Testament to announce sacred processions. In this manner, Stamos interweaves geological history and ancient human ritual. *The Altar* (1948, see fig. 18) also calls forth ritual and myth. Its two granite-like triangular forms support a horizontal slab. The scale of these elements relative to the picture surface also refers to such megalithic structures as Stonehenge (2,700–1,500 BCE). Because the altar is surrounded by a sensuous and delicately painted environment, the work indicates not a violent sacrifice but instead a benign ritual, one that unites humans with the forces of nature. In *The Sacrifice* (1946, pl. 5), Stamos has also used the table-like structure that appears in several works of this period, yet here he turns the table over so that its legs rise and undulate like plant stalks growing from the earth. As in the previous works, *The Sacrifice* communicates a benevolent view of the world.

Stamos' deep interest in ritual and myth was certainly encouraged by his close friendship with John Graham that began in 1947. A Russian immigrant and erudite figure, Graham had become an expert in tribal art and friend of several of the Abstract Expressionists, especially Gorky and Jackson Pollock. Stamos' relationship with Graham further connected him to the intellectual circles of his generation. In the 1930s, Graham had become particularly interested in American Indian art. Inspired by Karl Jung, Graham sought archetypal images that

embodied humanity's deepest feelings. He published his ideas in the book *System and Dialectics* where he wrote that the art of tribal races had a highly evocative quality that reflected the collective knowledge of past generations. The search for such universal meanings was an essential component of Stamos' work.

In 1947, Stamos traveled to the Sandia Mountains of New Mexico with the intent of viewing the American Indian petroglyphs, and photographs of the period show him studying those creations.[23] The Sandia Mountains had a profound effect on the artist. The three mountains, the so-called "Three Sisters," have been a sacred place for generations of Native Americans. The mountains were caused by magma eruptions through thin cracks in the earth's crust that occurred 13,000 years ago, leading to a fissure that is five miles long where the lava cooled into basalt rock. For Stamos, who wished to create from "inside the rock," the escarpment provided a portal into a moment of the earth's creation. Basalt combined with magnesium colored the rock light grey, and after long exposure to water and oxygen, the surface darkened to a rusty hue. Native Americans discovered that permanent signs could be made by using another rock to chip off this outer layer (fig. 23). Stamos' paintings *Canyon* (1948–9, fig. 24)

For Stamos the ongoing influence of Asian art entailed the use of introspection and intuition to emphasize the infinite capacity of nature for metamorphosis and the artist's creative identification with that process.

and *Untitled* (1950, pl. 10) express the powerful effect of his experience. The paintings are spacious in ways that reflect the vast areas of the Sandia Mountains. The layers of paint are equivalent to the geological layering of the escarpment, and Stamos' greys, blacks, and rusts are dominant in the colors of the mountains. The brush marks made on these paintings assert the artist's presence as did the petroglyphs made by humans some 12,000 years earlier. Furthermore, *Stonescape* (1947, fig. 25) evokes American Indian stoneware and is also related to Stamos' experiences in the Southwest. Stamos continued his American voyage by travelling to the Northwest Coast, an area where he could examine the tribal art of the Tinglit, Haida, and Kwakwaka'wakw peoples.

In Seattle, Stamos also visited Mark Tobey, whose art he admired, and the two artists exchanged paintings. Like Stamos' work, Tobey's abstract canvases were inspired by Native American art and by his feelings for the mysteries of the natural environment. Moreover, Tobey was influenced significantly by Asian art; he had spent several years between the world wars in China where he had studied Chinese calligraphy and brushwork at a Zen monastery. Sharing with Tobey a profound interest in Asian art and philosophy, Stamos was one of the few Abstract Expressionists so involved with Eastern thought—the others included Abram Lassaw, Richard Pousette-Dart, and Ad Reinhardt as well as Franz Kline and Robert Motherwell at somewhat later dates. Stamos had begun reading Japanese and Chinese poetry and philosophy as early

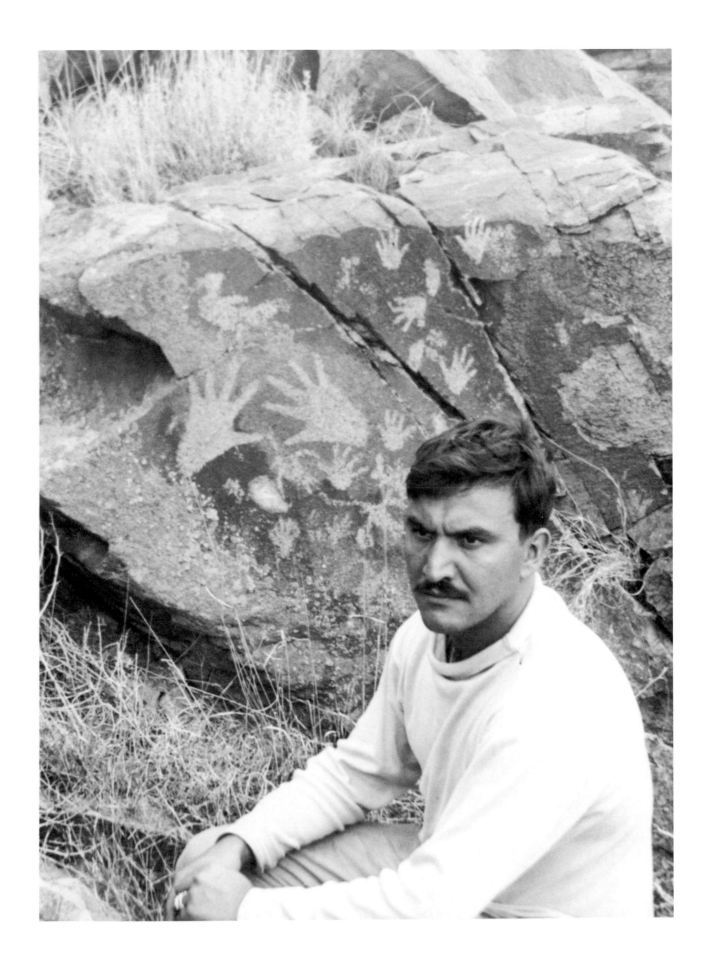

FIG 24

Theodoros Stamos, *Canyon,* 1948–49. Oil on masonite, 24⅜ x 19½ inches. Collection of Georgianna Stamatelos Savas

FIG 25

Theodoros Stamos, *Stonescape,* 1947. Oil on masonite, 29¾ x 38 inches. Los Angeles County Museum of Art, Gift from the Savas private collection, courtesy of Georgianna Stamatelos Savas, honoring the artist's wishes (M.2009.154)

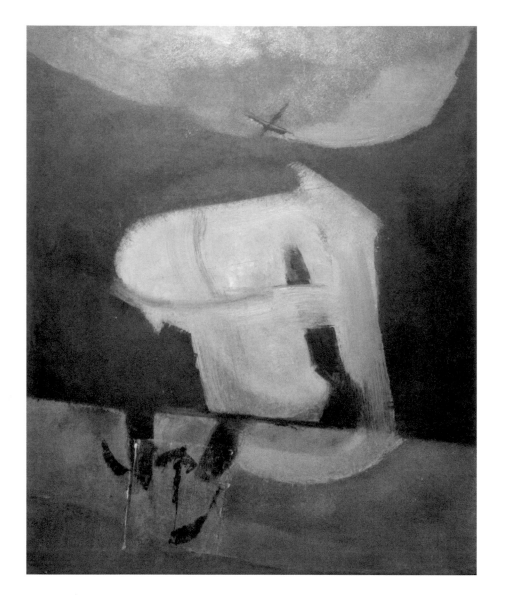

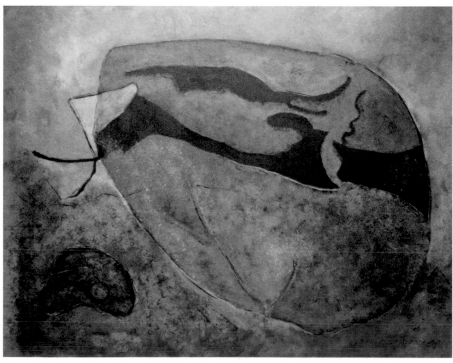

as 1941. At that time, he acquired Arthur Waley's *A Hundred and Seventy Chinese Poems*, one of the first authoritative translations of Chinese poetry into English and a book that Stamos kept close throughout his life. Soon afterwards, Stamos began to study illustrations of Asian art in Ernest Fenollosa's monumental two-volume study, *Epochs of Chinese and Japanese Art* (1912). Stamos also read with great interest Lafcadio Hearn's translations of Japanese stories and legends. At the turn of the century, Hearn's books like *"Out of the East": Reveries and Studies in New Japan* provided the most exciting tales of East Asia. Hearn was born in Lefkada, the home of Stamos' family, and thus had a special attraction for the painter. Most importantly, Stamos spent many hours studying the fine collection of Asian art at the Metropolitan Museum of Art. Stamos was also encouraged in his study of Asia by his close friend the poet Robert Price, who had spent his military duty as part of the occupying force in Japan and had developed a deep knowledge of its culture. Stamos stated about his prolonged study of Asian art:

> I can say I have found some degree of solace and enlightenment in trying to understand the art of China and Japan. After the looking in which I have been allowed, I think it is important to determine the elements of thought in the far eastern artists. What were the desires they sought to accomplish and what concepts of man and nature did they seek to accomplish.[24]

Stamos' conclusion was that the art of China and Japan is "abstract, symbolic and impersonal" and that "Eastern thought teaches us that things are created by the mind rather than the mind perceives existing things . . . In such a process, art becomes a kind of memory picture based on past experience or a series of such experiences."[25] Stamos believed that to achieve this "inner vision" the Asian artist became the object itself, a position that complemented his own early view.

Stamos' first artistic response to Asian art was based on Zen calligraphy. In works created between 1949 and 1955, particularly the Teahouse series, Stamos defined the paint surface with a series of rapidly made calligraphic marks. In the Zen view, the universe is one of wholeness where the outside world and inner spirit of the individual are united. According to this view, the individual must act freely and without encumbrance of ego to capture this spirit. Such actions would lead to *satori*, a state of enlightenment.[26] The bold brushwork of Stamos' Teahouse works, as in *Old Egypt* (circa 1952, pl. 11) and *Greek Orison* (1952, fig. 26), parallels the black and white brush drawing of Robert Motherwell and Franz Kline, both of whom also had an interest in the Zen aesthetic.

Stamos' lifelong interest in Asian art extended well beyond these calligraphic works and had a profound influence on the artist's color-field paintings, extending from such works as *Deseret* (1959, pl. 13) through the Sun Box series to the Infinity Fields. Stamos' paintings of large open fields of color that act as metaphors for the ephemeral and enigmatic character of nature

FIG 26

Theodoros Stamos, *Greek Orison*,
1952. Oil on canvas, 67 x 27 inches.
Whitney Museum of American Art,
New York, NY; purchase 53.15. Photo
by Geoffrey Clements

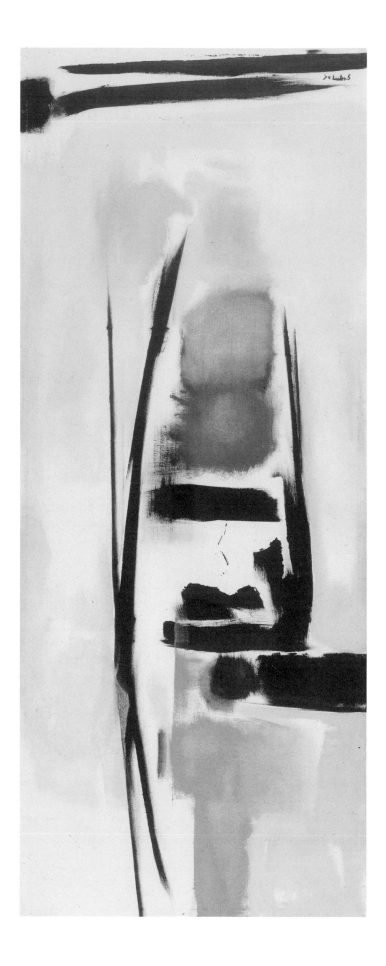

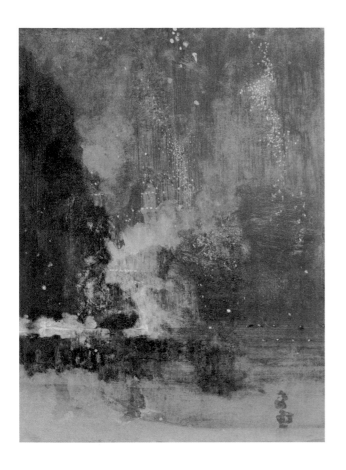

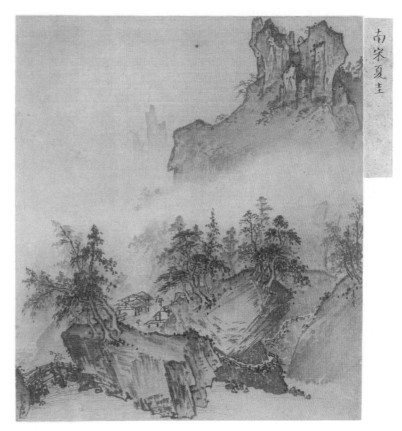

partly resulted from his identification with another western artist profoundly influenced by Asia. During the mid 1940s, Stamos traveled several times to Washington, D.C., to view James Abbott Whistler's paintings, especially his Peacock Room at the Freer Gallery. As seen in *Nocturne in Black and Gold—The Falling Rocket* (fig. 27), Whistler abandoned mere description and relied on his nearly abstract mode to communicate the lyricism of the world. Stamos provided a twentieth-century parallel for the evanescent light in Whistler's works, and in this context, Whistler's *Harmony in Blue and Gold: The Peacock Room* (1876–77, Freer Gallery of Art) was a model for Stamos of an all-encompassing experience created through art.

With regard to Asian art, Stamos has indicated that he was particularly interested in Song dynasty (960–1279 CE) landscape painting.[27] There was a rich collection of these works at the Metropolitan Museum of Art, and they were emphasized in Fenollosa's book. The paintings of this period are commonly termed "monumental landscapes" both because of the actual size of the hanging scrolls that typically measure five feet in height and because of the scale of the landscapes within them. As Wen Fong, former curator of Asian art at the Metropolitan Museum of Art, observes, landscapes like Xia Gui's *Mountain Market, Clearing with Rising Mist* (1200–1235, fig. 28) express "a profound belief in communion with nature, a cosmic vision of man's harmonious existence in a vast but orderly universe."[28] In contrast to the bleak

FIG 27
James Abbott Whistler, *Nocturne in Black and Gold—The Falling Rocket*, 1875. Oil on panel, 23¾ x 18¼ inches. Detroit Institute of Arts, Erich Lessing/Art Resource, New York, NY

FIG 28
Xia Gui, *Mountain Market, Clearing with Rising Mist,* Early 13th century, 1200–1235. Southern Song Dynasty. Album Leaf; ink on silk, 9¾ x 8⅜ inches. The Metropolitan Museum of Art, New York; John Stewart Kennedy Fund, 1913 (13.100.102). © The Metropolitan Museum of Art/Art Resource, New York, NY

spirit of the artist/recluse found during the earlier Tang period, these works emphasize the vastness of nature and its infinite capacity for metamorphosis. The Song dynasty works express a view that the artist looks into nature and looks into himself at the same time. The interactive relationship between the two, exterior/interior, is circular and dynamic as "the artist sought to describe the external truth of the universe, he discovered at the same time an internal psychological truth."[29] In *Mountain Market, Clearing with Rising Mist*, the vastness of open space resembles the space depicted by Stamos in *Deseret*. Both works emphasize an atmosphere that is endlessly transformed by changing light. Stamos called this aspect of Chinese painting "the voids of infinity."[30] For Stamos the ongoing influence of Asian art entailed the use of introspection and intuition to emphasize the infinite capacity of nature for metamorphosis and the artist's creative identification with that process.

Stamos's field paintings, like *Delphic Shibboleth* (pl. 12), feature the subtle layering of space—one defying rational analysis—that Stamos admired in Chinese painting. In this work, the canvas is filled with delicate small brushstrokes that seem to float across the surface as if blown there by a wind. These slow-paced gestural markings create multi-hued color fields that move vertically through the canvas. Their soft edges that blend into one another do not allow

The 'Sun Box' series, therefore, are the most logical development of the concept of a field. The paintings are never hardedge although they have the appearance of hard edge through a control of light and intention.

them to coalesce into specific shapes. Rather, they maintain an ambiguity and mutability that registers Stamos' openness to external impressions which are subject to constant change. Stamos referred to these paintings as "grand space color forces that defy the plane and a quiet energy."[31] While the irregular fields of color of Stamos' paintings of this period superficially resemble fissures in the most iconic works by Clyfford Still, whom Stamos met in 1946, the gentle lyricism of Stamos' work is actually the opposite of the violence suggested by Still's jagged, shredded edges, and somber colors.

Stamos' field paintings unite Eastern and Western traditions. In 1948 through 1949, Stamos made his first trip to Europe with his friend Robert Price. He visited France, Italy, and Greece. From that trip, Stamos singled out Claude Monet's *Les Nympheas* at the Musée de l'Orangerie and Giovanni Battista Tiepolo's ceiling painting seen in Italy as particularly important for him. *Les Nympheas* are the culmination of Monet's late style in which the French artist united an exterior and interior vision of nature, one that he described in terms of musical harmonies. Stamos found significant parallels between Monet's feelings for the cycles of nature with his own discoveries in Asian art. Tiepolo's dramatic ceiling paintings also provided the artist with a model for forces of nature presented through dazzling light and sun-drenched colors. In paintings such as *Day of the Two Suns* (1963, fig 29), Stamos fused his interest in

FIG 29
Theodoros Stamos, *Day of the Two Suns*, 1963. Oil on canvas, 60 x 43¾ inches. Walker Art Center, Minneapolis; Gift of Mr. and Mrs. Edmond R. Ruben, 1969

employing a dense palette and lush gesture with characteristics of Asian art—calligraphic brushwork and negative space. He would develop this reductive, divided composition in the series that came later. But perhaps Stamos' most important experience during his first European trip was visiting Greece. He traveled to his mother's homeland of Sparta, and while the artist remembered the privation of Greece as it just emerged from World War II, he was struck most by the clarity of light, the rocky coastline, and open spaces. These would all become major influences on his art.

Between 1962 and 1970, Stamos created his Sun Box series. The Sun Boxes are mostly horizontal in orientation, and the surfaces are modulated by rectangles of contrasting color, as well as horizontal bars in many cases. These works embody introspection, harmony, and delicate balance. They represent a period in which Stamos sought to objectify his creative impulse. Stamos wrote about these paintings: "The 'Sun Box' series, therefore, are the most logical development of the concept of a field. The paintings are never hardedge although they have the appearance of hard edge through a control of light and intention."[32]

The period of the 1960s was one of relative calm in Stamos' life and provided an opportunity to develop this thoughtful, classical approach to his art. During this period, Stamos spent a good deal of time at the house designed for him by artist Tony Smith in East Marion on the North Shore of Long Island. This area of extreme natural beauty, on an ancient glacial moraine, features not only views of the ocean but rich geological formations that revealed the prehistory of the earth. Stamos collected from the area colorful specimens of stones and sea life that became one source for the coloration of his paintings. At his East Marion home, Stamos cultivated beloved gardens within rectangular boundaries and carefully observed changing light modulated by the nearby ocean. In the spirit of integrating exterior/interior visions of nature that had been the center of Stamos' art since the 1940s, he commented at that time that he wished to "live on the horizon of mind and coast."[33] In works like *Classic Yellow Sun-Box* (1968, pl. 18), the sky blue void with its subtle value changes is brought into focus by the large red-umber rectangle and the horizontal band beneath it. Another work, *Olivet Sun-Box #II* (1967, pl. 16), balances a rose colored field against a smaller off-center mauve rectangle and thin yellow and blue horizontal bands. For Stamos, the rectangle is a metaphor for the light and energy of the sun that brings life to all things. Its "boxed-in" form allowed the artist to create a controlled dialogue with the void surrounding it. Stamos' impulse toward a classical approach to the intuitive process in these works owes something to Joseph Albers' Homage to the Square series. Stamos knew Albers' work well and taught at Black Mountain College in 1950, the year after Albers left the institution. During that year critic Clement Greenberg was also in residence, and Kenneth Noland was one of Stamos' students (Stamos painted *North Carolina Landscape* [1950, fig. 30] during this period.). In 1955,

Greenberg published his article "American Type Painting" which sought to objectify abstract art by strictly discussing it in terms of the artist's response to the physicality of the canvas and materials.[34] Greenberg's critique was followed by the stripped-down geometry of minimalism during the 1960s. Stamos' Sun Boxes respond to this era, but they maintain the colors of the outside world, delicately modulated surfaces, and forms with imperceptibly irregular lines that proclaim the artist's continued inspiration in nature and more his lyrical stance. In this regard, Stamos' Sun Boxes reach beyond the cool rationalism found in Albers, the late Bauhaus, and minimalism to the Suprematist paintings of Kazimir Malevich who insisted that his works were marked by an "inner life" and composed according to pure intuition.[35] When asked to define suprematism, Malevich did so in words that would resonate with Stamos, calling it "the supremacy of pure feelings." Stamos identified with Malevich (fig. 31) a deep interest in icon painting which, as will be explored below, is motivated by the universal visual language found in that spiritual art form.

FIG 30
Theodoros Stamos, *North Carolina Landscape*, 1950. Oil on masonite, 36 x 48 inches. National Gallery of Art; gift from the Savas Private Collection, courtesy of Georgianna Stamatelos Savas, honoring the artist's wishes

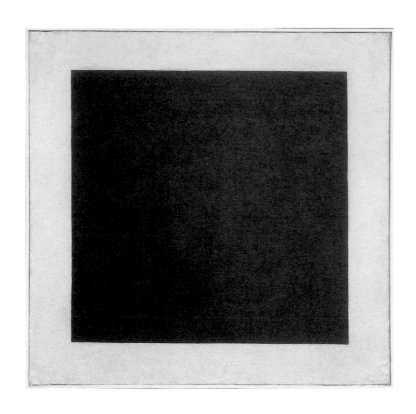

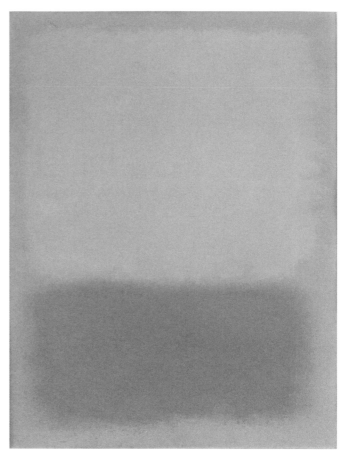

The search for a universal painterly language that expressed a profound inner vision was a concern that Stamos shared with Rothko. The color, light, and suggestion of infinite space of Stamos' works bear a kinship to the more radiant paintings of Rothko, who was Stamos' closest friend of those years. The two artists became particularly close after Stamos left Betty Parsons Gallery in 1957, and Rothko became a mentor for Stamos. In works like *Untitled* (1968, fig. 32), Rothko created an intensely personal style based on self-transcendence, a worldview keenly admired by Stamos. Rothko's thin sheets of veiled color in roughly rectangular configurations strike a sustained note of even-burning intensity while his surfaces remain sensuous and poetic. The boundaries between Rothko's color forms are deliberately left hazy to suggest transformation. While there are relationships between the structure of Rothko's works and the Sun Boxes (fig. 33), the most powerful interaction between Stamos' art and that of Rothko came in the Infinity Fields where Stamos' color transitions are used to suggest new metamorphic life within structures of supreme unity.

In 1970, Stamos' life was thrown into crisis when Rothko committed suicide in February of that year. Stamos had known Rothko since the 1940s, and he had been particularly close to him since 1965. Rothko was buried on Stamos' property in East Marion, and Stamos, together with

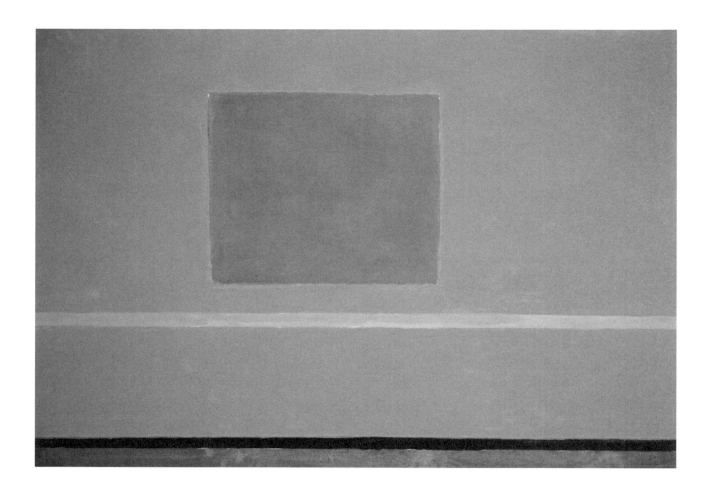

FIG 33
Theodoros Stamos, *Olivet Sun-Box #II*, 1967. Acrylic on canvas, 48 x 70 inches. Signed, titled, and dated verso: "Stamos, OLIVET SUN-BOX II, 1967"

the painter Roy Edwards, who had worked as a studio assistant for Rothko during the creation of the chapel paintings, was asked to oversee the installation of his works in the Rothko Ecumenical Chapel in Houston. Stamos' admiration for Rothko's work was enormous. Rothko's death was followed in 1971 by litigation filed against the executors of his estate of which Stamos was one. The suit, which accused the executor of conflict of interest in selling Rothko paintings to Marlborough Gallery, continued for six long years. Eventually, the suit was decided against the executors. The consigned paintings were returned to the estate, and damages were awarded the Rothko heirs.[36] Significant questions remain about Stamos' actual involvement in the Marlborough transactions. The court decision was personally devastating. The artist presented a stoic demeanor in the face of the assertions in the popular press that he had betrayed his old friend—assertions that he was denied the opportunity to express publicly. As a result, however, Stamos became increasingly isolated from a number of art-world friends, and his work became less evident in the New York art scene.

Seeking solace and peace after Rothko's death, Stamos made his second trip to Greece. He visited many of the country's ancient archaeological sites and most importantly traveled to Lefkada, his father's birthplace. Lefkada is a dramatically rugged island set in the Ionian Sea. The

island comprises three hundred square kilometers with a native population of only 23,000 people. Seventy percent of the island is covered with mountains, and steep white cliffs plunge into the sea on its southern edge. The island is also known for its red soil, and on the interior its upper plains allow vast views toward the ocean; its lower valleys are rich with a variety of vegetation that includes olive trees, cypresses, pines, and a special variety of oak tree. The island also features a number of cataracts that become dramatic waterfalls during the spring rains.

The history of Lefkada is equally rich. Legend has it that the Greek poet Sappho threw herself into the sea from the white cliffs because of her unrequited love for Phaon. Human

In the Infinity Fields, Stamos no longer felt the need to depict ancestral or mythic images. He did not require the invention of organic creatures as a grounding point for his work.

habitation on Lefkada can be traced back to the Paleolithic era. Archaeological studies conducted around 1900 of the ancient city of Nydri revealed a Copper Age settlement (2,000 BCE), and some speculate that Lefkada may be identified with ancient Ithaca, the home to which Odysseus returned in the Homeric tales. Lefkada participated in the Peloponnesian Wars and later (343 BCE) became an ally of the Athenians in order to fight the Macedonians.

Both the geography of Lefkada and its ancient history had enormous appeal to Stamos. Despite the fact that Lefkada is only fifty miles from the Greek mainland and is connected to it by bridges, it has remained one of least developed of the Ionian Islands. On the island, Stamos befriended members of his father's family. He loved the simple uncomplicated life of the market and village. The drama and variety of nature on the island was endlessly fascinating to him, and he frequently hiked the island absorbing its wonders.[37] Most importantly, he could paint there without distractions. Beginning in the 1970s, Stamos spent over half of each year in Lefkada, largely leaving the New York art world behind.

Immediately after his first visit to Lefkada, Stamos began his Infinity Field series, a group of works that lasted from 1970 until 1993. These paintings are partly based on his experience of Lefkada. Their overall breadth recalls the long open vista of the island. For instance, *Infinity Field-Lefkada Series* (1977, pl. 26) recalls the deep red earth for which Lefkada was known, and *Infinity Field-Lefkada Series #5* (1978, pl. 31) visualizes the blue sky and the foaming sea beating against the island's tall cliffs. *Infinity Field-Lefkada Series #3* (1978, pl. 29) suggests the white cliffs with the colors beneath reflecting their underlying strata and jagged lines their deep fissures. In these works, color references and a feeling for space comprise their primary means of association with the outside world.

In the Infinity Fields, Stamos no longer felt the need to depict ancestral or mythic images. He did not require the invention of organic creatures as a grounding point for his work. Nor did he locate his experiences of nature in terms of particular seasons. Rather, Stamos became

more closely wedded to the "idea" behind these phenomena. In 1985, he told the art historian Dore Ashton, "I am concerned with the idea of a thing."[38] In Stamos' Infinity Fields, the idea manifests itself in terms of three reciprocal elements: light, space, and time. These are simultaneously the most universal and elusive forces in our world. Stamos came to them through a lifetime of thinking about painting, its meaning, and its relationship to human experience.

In the *Infinity Field* series, Stamos employs a number of painterly devices to promote the idea of the unity of light, space, and time. The works are largely vertical in orientation, and he increased their scale. They fill our visual field, but he rarely allowed them to exceed human measure. In these works, Stamos' painted surfaces became richer than at any point in his career. featuring complex layers of pigment that reveal subtle variations in a single color. *Infinity Field, Lefkada* (1971, pl. 22) is an example of the nearly endless values of blue distributed freely across the surface. The space constantly shifts so that the eye moves from one seemingly homogeneous area to another. When Stamos used more than one color, they were adjusted chromatically so that they comprise equally distributed intensities, and there are no sudden chromatic transpositions; thus the unity of the field is maintained. When bars appear in the field, as in *Infinity Field-Lefkada #11* (1978, pl. 30), they do not touch each other, so they neither form shapes nor define measurable space. Other markings with ragged edges do not appear as shapes but instead as fissures in the planes leading into a deeper and still undefined space.

Stamos' colleague, the painter Ed Meneeley, observed the artist as he painted a number of the Infinity Fields in Lefkada. He noted that Stamos never attacked the canvas, but instead, "he approached it gently."[39] Stamos often would work the acrylic paint wet onto wet by applying moisture to the canvas between each stage of painting. Meneeley recalls that Stamos often

The Infinity Fields use color and light to unhinge the viewer from linear time and measurable space.

employed industrial sponges and rags; traditional brushes were used primarily for accent marks. Stamos would place a trough beneath the paintings that would catch pigment as it ran off the surface. He would then dip the sponges in that trough in order to add layers of pigment. This technique accounts for the visual unity and extremely subtle modulation found in the Infinity Fields. Further, Meneeley recalls that Stamos prided himself on the poetry of the colors in these works. In the Infinity Fields, Stamos would spend long periods between the painting sessions contemplating the works and musing on subtle changes that he would make in them.

As Stamos became deeply involved in the Infinity Fields, two reference points were important. One of these reached back into the nineteenth century. In 1953, Stamos wrote of "America's great nature painting . . . the spiritual vistas of the Hudson River School . . ."[40] Before art historians explored the subject, Stamos recognized that Hudson River School painting, influenced by "natural theology," transformed the exterior world into an interior vision that captured

the mood of nature and its spiritual meaning. In this regard, Stamos' *Infinity Field-Lefkada Series* (1972, pl. 23) might be compared to George Inness' visionary rendering *Niagara* (1889, fig. 34). Stamos cited Inness as one of the American artist who understood that "the manner in which they rendered natural forms was always subservient to the real image."[41]

Stamos' other touchstone for the Infinity Fields was even more significant. In late conversations with his friend sculptor Morfy Gikas, Stamos identified Henri Matisse as the artist most important to him throughout his career.[42] While Stamos had been reflecting on Matisse's art ever since the 1940s, his long-held passion for Matisse reached a climax in the Infinity Fields. Like Stamos, Matisse always looked to the outside world for inspiration and through simplification translated that world into symbols meant to communicate its underlying essence. While Stamos remained distant from Matisse's more decorative and ornamental aspects, he was deeply attracted to Matisse's lyrical vision (fig. 35). Matisse demonstrated that color itself could express the full range of visual and emotional responses to the world. Stamos was especially impressed by the more abstract works by the artist like *French Window at Collioure* (1914, fig. 36), but Matisse's late works also had special meaning to him as he entered the later part of his own career. In Matisse's *découpage* works, the ailing artist literally "cut into color" to create radiant upsurge at the twilight of his long life.

The *Infinity Fields* use color and light to unhinge the viewer from linear time and measurable space. In these works the viewer and art object enter into a shared state. In 1971, Stamos stated, "Through my experiences I have learned that it is possible for color to give off light. Therefore, the reverse is true; for colors to absorb light. The 'Infinity Series', which are built as

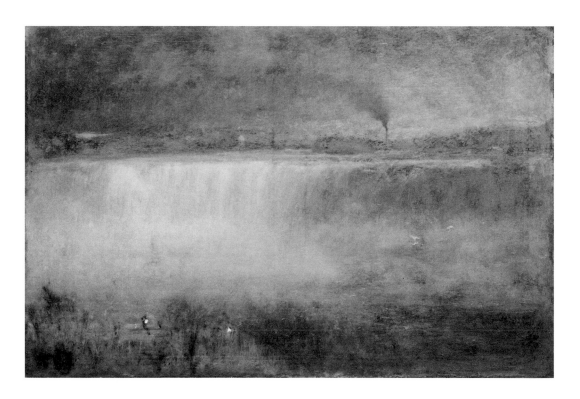

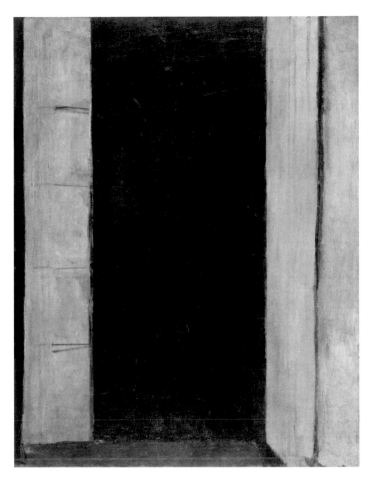

structures, strive for both possibilities."[43] The unity between participant and object through light that Stamos achieves in the Infinity Fields connects him to larger ideas that are essential to the modern age. In 1926, Niels Bohr, pioneer of quantum mechanics, proposed the theory of "complementarity" that could be used to fuse some of the fractious elements of the new physics. He appreciated that the observer and observed, while seemingly opposites, are a reciprocal indivisible pair, and he proposed that there is no such thing as an objective reality separate from the observer. In Bohr's thesis, combining the observer and observed creates a reciprocal duality that forms a seamless unity and a "profound truth."[44] Stamos' Infinity Fields aim at such a synthesis.

In 1983, Stamos traveled together with his cousin from Lefkada to Jerusalem. The city with its 1,200 synagogues, 150 churches, and 70 mosques made a powerful impression on him. Stamos visited such sites as Mount Zion, which is thought to be the location of the tomb of King David and site of the Last Supper, and the Church of the Holy Sepulcher, a Christian pilgrimage site for two thousand years. Stamos had a long interest in religion, not in terms of a particular faith, but as an expression of the mystery of life. The myth and ritual of religious practices connected to interests that had occupied him since the 1940s. Stamos responded to the experience

FIG 35

Theodoros Stamos, *Infinity Field-Knossos*, 1973–74. Acrylic on canvas, 90 x 48 inches. Titled and dated verso: "INFINITY FIELD, KNOSSOS, 1973–4"

FIG 36

Henri Matisse, *French Window at Collioure*, 1914. Oil on canvas, 46 x 35½ inches. Musée National d'Art Moderne, Centre Georges Pompidou, Paris. Photo: Philippe Migeat; CNAC/MNAM/Dist. Réunion des Musée Nationaux/ Art Resource, New York, NY. © Succession H. Matisse, Paris/ARS, New York, NY

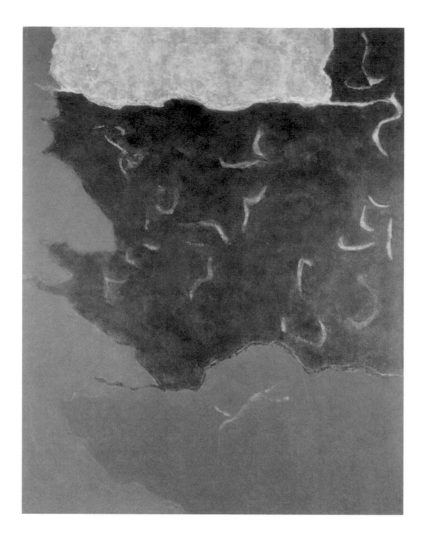

in Jerusalem by conceiving of his paintings in terms of the mysteries presented by religious faith. In *Infinity Field–Jerusalem Series* (1983–84, pl. 35, fig. 37) the artist created a surface of thinly applied and scrubbed paint to suggest an ancient parchment with its tattered edges. On that parchment, Stamos has inscribed calligraphic signs of his own invention that seem to represent an indecipherable language. *Infinity Field-Jerusalem Series* harkens to Stamos' earlier interests in the mysteries of the Old Testament. *Saga of Ancient Alphabets* (1948, fig. 38) looks as if its marks were inscribed on an ancient wall. In its lower area, the bar with three rising flame-like lines seem to form the Hebrew letter shin, symbolic of the flame of divine revelation. The form also can be read as the Greek letter sigma, or S, which the artist sometimes used to sign his paintings.

In the Jerusalem paintings and throughout Stamos' career, the tradition of Eastern Christian icons is essential. Icons like *Saint Jerome and the Lion* (early 15th CE, fig. 39) schematize forms and compress space in order to communicate a divine realm. The figures are twisted to conform to a frontal plane and distance is compressed by overlapping the planes. The rich colors and gold grounds of these works also serve to remove them from everyday reality. In the Eastern tradition, painted icons are sacred objects, having spiritual and

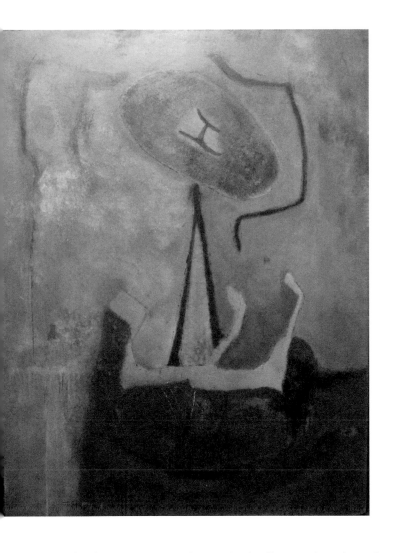

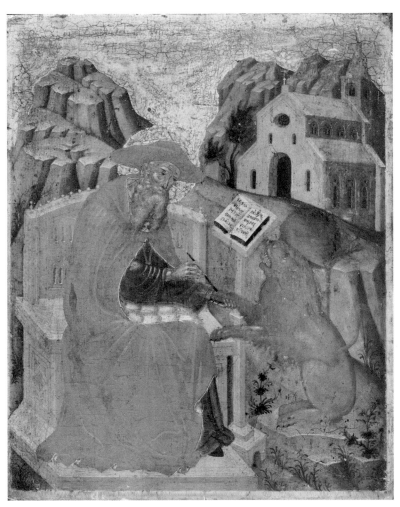

healing powers much as saints' relics are thought to have in the Western church. The Eastern icons are painted by trained clergy who follow strict aesthetic rules in their creation, and the common term used for the creation of an icon is "to pray." While Stamos' works remain painterly and intuitive in the framework of modernism, their frontal structure and mysterious simplicity have an iconic character, and Stamos invests the works with a depth of meaning that is connected to his understanding of the icon tradition.

Edge of Burning Bush (A) (1986, pl. 38) introduces drama and conflict into Stamos' late works. This painting reconfigures the harmony found in other examples of the Infinity Field—Lefkada series. Red is one of the most symbolically loaded colors in human culture. Its associations range from fire and blood to royalty. In icon painting, red is the color of divinity while blue is the color of humankind. The title of Stamos' work refers to the passage in Exodus (2:15–3:10) in which God reveals himself to Moses in the form of a burning bush. In the story, Moses is instructed not to step too close to the burning bush lest he be destroyed. Similarly, the red color of *Edge of a Burning Bush (A)* dominates only the left segment of the work. Three-quarters of the painting surface is covered by an earthy brown pigment modulated by blue calligraphic

FIG 40

Theodoros Stamos, *Infinity Field-Torino Series #7,* 1986. Acrylic on canvas, 72 x 48 inches. Signed, titled, and dated verso: "Stamos, INFINITY FIELD-TORINO SERIES #7, 1986"

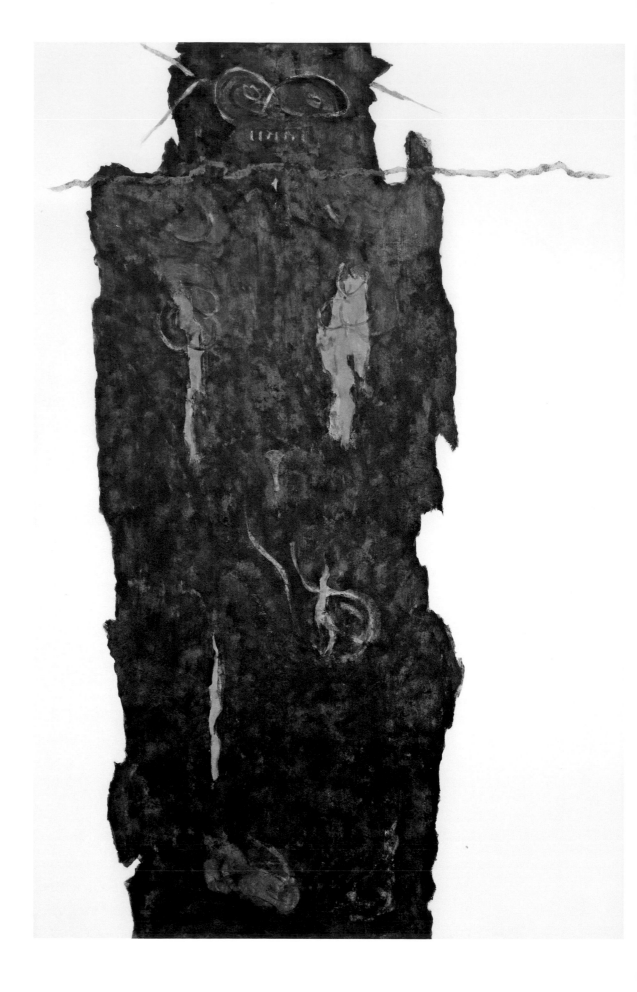

strokes. Connecting to Stamos' early geological interests, the surface looks like rock cooling on a field of burning lava. The duality between desire for universal understanding and preservation of our physical, and thus fallible, human condition is the underlying theme of this work.

During the 1980s, Stamos also became fascinated by the Shroud of Turin, which was given to the Holy See around the time that Stamos was in Jerusalem. The Shroud, which is housed in the Cathedral of Saint John the Baptist in Turin, Italy, became an inspiration for Stamos' Torino series. In Christian doctrine, the Shroud conjoins the divine and physical presence of Christ because it is believed to be an image inscribed in the cloth that was placed over Christ's body at the time of his burial. It is considered by many the first icon. Stamos was neither believer nor disbeliever in the Shroud. Instead, his interest was the cultural power of this object and the manner in which it inspires human ritual and faith. Because the Shroud of Turin is a two-dimensional image transferred onto cloth, it is in essence similar to a painting

Stamos had a long interest in religion, not in terms of a particular faith, but as an expression of the mystery of life. The myth and ritual of religious practices connected to interests that had occupied him since the 1940s.

on canvas. Stamos' *Infinity Field-Torino Series #7* (1986, pl. 39, fig. 40) features a ragged vertical form in blues and blacks set against a white ground. The proportions and outline of this form are clearly reminiscent of the images on the Shroud. The blue/black pigment is layered over red, which appears in irregular patches throughout it, as if a more numinous presence were fighting its way up from beneath the dark surface. Although Stamos would continue to paint powerful works for another eight years until his death in 1997, the Infinity Field-Torino paintings provide a powerful expression of concerns central to his art. While acknowledging the temporal state of all human endeavors, they strive toward spiritual expression.

Theodoros Stamos is a complex and important figure whose works embody significant intellectual and cultural tendencies of their age. Stamos' early biomorphic paintings were leading works in the Abstract Expressionist quest for a universal visual language based on archetypal symbols. In these paintings and throughout his career, Stamos found inspiration in the natural world, but he understood early on that nature was a synthesis of observed fact and creation in the mind of the beholder. In his search for profound meaning in art, Stamos delved into such scientific tendencies as Darwinism and "natural theology." He identified with artists like Arthur Dove and Gorky who abstracted organic life, and he embraced Asian philosophy and art for its unity of creator and object.

Through these sources and as a result of his distinctive personality, Stamos imagined nature not primarily as competitive and destructive, but as poetic and generative. This viewpoint allowed the artist to envision procreative energies in the face of the horrors of World War II. Stamos' worldview prompts us to look for this more benign approach to the biological world in the other Abstract Expressionists.

Stamos' progressive internalization of nature and identification with its underlying forces developed throughout his long creative life and culminated in his most extensive group of works, the Infinity Fields. In these paintings, light, space, and time are the primary themes. It may be argued that Stamos believed the creation of these works, marked simultaneously by extreme unity and complexity, paralleled the essential mystery of nature as he understood it.

In 1953, Theodoros Stamos wrote a statement that provides the most fitting conclusion for this essay:

> Why Nature in Art is the large question I have been trying to answer for a long time. As I dwell and work with this broad subject, it grows into the problem of what, how and why nature in art. And that is just the beginning of my queries. I wonder: What is the spirit which guides and expresses the physical world? What is the secret of silence? What is the motive of rhythm? What lies beyond the challenge of my unpainted canvas? I can assure you I am nearly winded by these questions.[45]

Notes

The author wishes to thank Morfy Gikas, Ed Meneeley, James DiMartino, Diran Deckmejian, and Charles Duncan for their generous assistance.

1 Barnett Newman, "Stamos" in *Theodoros Stamos* (New York: Wakefield Gallery, 1947). Reprinted in *Barnett Newman: Selected Writings and Interviews* (New York: Alfred A. Knopf, 1990), 109–110. Numenistic refers to the belief in animistic spirits inhabiting a place or an object.

2 Son of Elihu Root, Edward Root became an important collector of progressive American art of the twentieth century, from The Eight to Abstract Expressionism.

3 Barbara Cavaliere is the major Stamos scholar, and her work is indispensible for study of the artist. See especially "Theodoros Stamos in Perspective," *Arts* 52, no. 4 (December 1977): 104–115. See also Anna Kafetsi, ed., *Theodoros Stamos 1922–1997: A Retrospective* (Athens, Greece: National Gallery and Alexandros Soutzos Museum, 1997) for an authoritative study of the artist.

4 Leen reportedly gave the artists the freedom to position themselves for the photograph. Rothko chose a prominent place in the foreground that created a triangle with him, Stamos, and Newman as its sides. Klaus Ottmann, *The Essential Mark Rothko* (New York: Abrams, 2003), 70.

5 Interviews with Stamos' students and colleagues Diran Deckmejian and James DiMartino on December 2, 2009, Sherman, Connecticut. Notes for interviews are in author's files, Easton, Pennsylvania.

6 Sherrye Cohn, *Arthur Dove: Nature as Symbol* (Ann Arbor, Mich: UMI Research Press, 1985).

7 A loosely organized group, the Ten formed in 1935 and exhibited together for approximately four years at galleries including Montross and Mercury.

8 Stamos' student and later colleague James DiMartino recalls being taken by Stamos to Avery's studio. Interview with the author December 2, 2009, Sherman, Connecticut. Notes in author's files, Easton, Pennsylvania.

9 Interview with Georgianna Savas, Stamos' sister and executor of the Stamos estate, January 6, 2010, New York City. Notes for interview in author's files, Easton, Pennsylvania.

10 Cavaliere, "Theodoros Stamos in Perspective," 106.

11 Darwin did not use the term "survival of the fittest' in the early volumes of *On the Origin of Species*. It was first used by Herbert Spencer in terms of economic theory to describe market competition. By this overall concept, Darwin did not mean in better physical shape. Rather, he meant better adapted to the immediate environment. This latter meaning is closer to the sense of Stamos' paintings.

12 Charles Darwin, *The Power of Movement in Plants* (New York: D. Appleton and Company, 1881), 196–200, 490–492.

13 The Rev. William Buckland, *Geology and Mineralogy Considered with Reference to Natural Theology* (London: William Pickering, 1836). See especially Chapter II, "Consistency of Geological Discoveries with Sacred History."

14 Thomas B. Hess, "Stamos: Abstracting the Ocean," *Art News* 45, no. 12 (February 1947): 34.

15 Interview with Georgianna Savas, op. cit. Also see "Interview of Theodoros Stamos by Irving Sandler," New York, April 23 and 29 and May 6, 1968, Theodoros Stamos papers, 1922–2007 Archives of American Art, Smithsonian Institution. This interview is one of the most extensive statements by Stamos about his art, influences, and relationship with the art world. The interview is reprinted in *Theodoros Stamos 1922–1997: A Retrospective*, 419–454.

16 Theodoros Stamos, "Why Nature in Art," an undated text in the archives of Georgianna Savas. It was delivered as a lecture by Stamos at numerous museums and universities beginning in 1953. The text was first published in *Theodoros Stamos 1922–1997: A Retrospective,* 266–7.

17 Interview with Georgianna Savas.

18 The Museum of Natural History was an important inspiration for many of the Abstract Expressionist artists. See Jeffrey Weiss, "Science and Primitivism: A Fearful symmetry in the Early New York School," *Arts* 57, no. 7 (March 1983): 81–87 for an authoritative study of this issue. In contrast to Weiss's overall thesis, Stamos found solace, not fear, in the presentations of natural and human wonders at the museum.

19 Stamos, "Why Nature in Art."

20 Cavaliere, "Theodoros Stamos in Perspective," n. 18.

21 Sir James Frazer, *The Golden Bough: A Study in Magic and Religion* (1890; reprint, New York: Macmillan, 1951), 13–43, 787–792.

22 Cited in Stephen Polcari, *Abstract Expressionism and the Modern Experience* (Cambridge: Cambridge University Press, 1991), 387 n. 20.

23 See Robert Carlton Hobbs and Gail Levin, *Abstract Expressionism: The Formative Years* (New York: Whitney Museum of American Art, 1978), 123.

24 Stamos, "Why Nature in Art."

25 Ibid.

26 One of the prominent conduits for Eastern thought in New York was D.T. Suzuki who gave a series of lectures at Union Theological Seminary in the early 1950s that were well attended by avant-garde artists.

27 Kenneth B. Sawyer, *Stamos* (Paris: G. Fall, 1960), 14.

28 Wen C. Fong, "Of Nature and Art: Monumental Landscape," in *Asian Art*, ed. Rebecca M. Brown and Deborah S. Hutton (Malden, Mass: Blackwell Publishing, 2006), 279.

29 Ibid., 281

30 Stamos, "Why Nature in Art."

31 Questionnaire, no date. Theodoros Stamos papers, 1922–2007. Loaned by Theodoros Stamos; microfilmed by the Archives of American Art, Smithsonian Institution. [Microfilm reel number N60–67]. Cited hereafter as Stamos papers, Archives of American Art.

32 "Statement," no date. Box #1 and folder 51/30, Stamos papers, Archives of American Art.

33 Quoted in Hans Dichand, "A Visit to Lefkada," in *Theodoros Stamos: The Dark Paintings* (Zurich: Turske & Turske, 1985), 10.

34 Clement Greenberg, "American-Type Painting," *Partisan Review* 22 (Spring 1955): 179–196.

35 Stamos mentioned the originality of Malevich's art in Questionnaire, no date, Theodoros Stamos papers, Archives of American Art [Microfilm reel number N70–67].

36 For further discussion of the case, see John Bernard Myers, "Mark Rothko & the Rothko Case: Notes, Memories, Observations," *The New Criterion* 1, no. 6 (February 1983):10–30; and Daniel Wise, "Lawyer Helps Artist Regain Status After IRS Nightmare," *New York Law Journal*, 14 July 1988.

37 Interview with Ed Meneeley, January 10, 2010, Lehighton, Pennsylvania. Notes in the author's file, Easton, Pennsylvania. Meneeley and Stamos met and became friends in the 1950s; Meneleey had photographed Rothko's paintings, and Rothko recommended his work to Stamos.

38 Quoted in Dore Ashton, *Stamos* (New York: Kouros Gallery, 1985), n.p.

39 Ed Meneeley, interview with the author, January 10, 2010, Lehighton, Pennsylvania. Tape recording is in author's file, Easton, Pennsylvania.

40 Stamos, "Why Nature in Art."

41 Ibid.

42 Telephone interview with Morfy Gikas, Stamos' colleague, February 2, 2010. Notes in author's file, Easton, Pennsylvania. Gikas recalls that she expected Stamos to cite Picasso but he named Matisse without hesitation.

43 Stamos statement in Marcia Tucker, *The Structure of Color* (New York: Whitney Museum of American Art, 1971).

44 Leonard Shlain, *Art & Physics: Parallel Visions in Space, Time, and Light* (New York: Morrow, 1991), 430.

45 Stamos, "Why Nature in Art."

PLATES

1

The Green Sky, 1944
Oil on masonite, 23¹⁵/₁₆ x 29¹⁵/₁₆ inches
Signed and dated lower left: "T. STAMOS '44"
Signed, titled, and dated verso: "STAMOS 'Green Sky' 1944"
Collection of John and Denise Ward

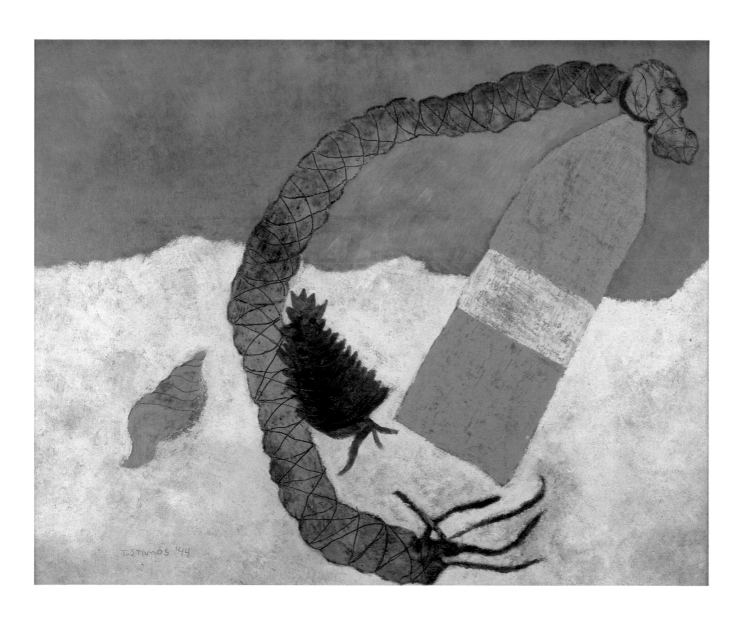

2
Undersea Fantasy, 1945
Oil on board, 14 x 20 inches
Signed, dated, and inscribed lower left: "T. Stamos '45 N.Y.C."
Inscribed lower center: "To Ben Weiss From the Greek Stami"
Collection of Stephen and Mary Craven

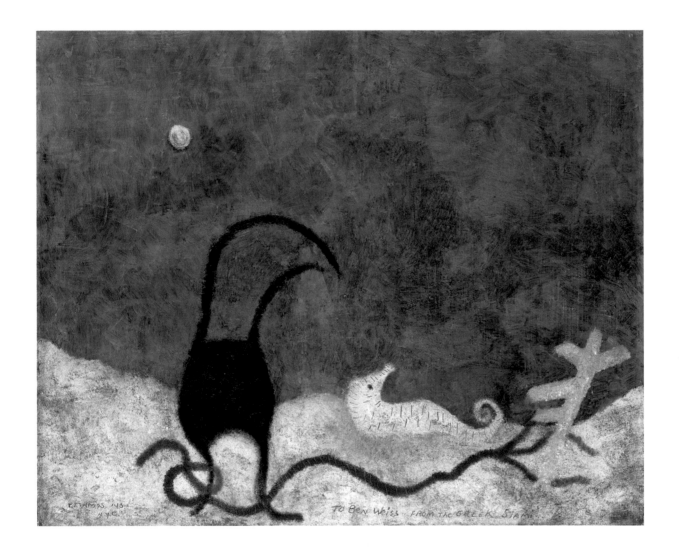

3

Coney Island, 1945
Oil on masonite, 24 x 30 inches
Signed, titled, inscribed, and dated verso: "Coney Island, Theodoros STAMOS, 146 5th N.Y.C.–U.S.A., 1945"
Collection of Nestor and Kathy Savas

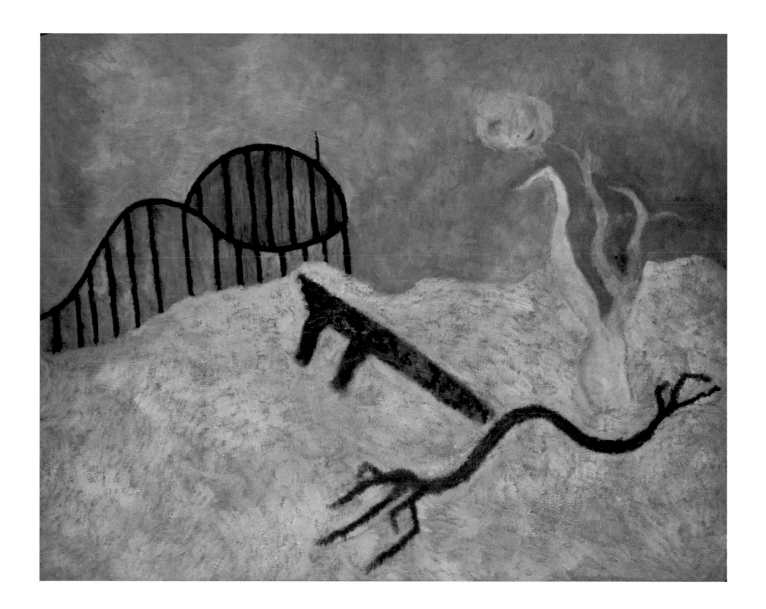

4
Nautical Warrior, 1946–47
Oil on masonite, 17¹³/₁₆ x 24⅛ inches
Signed and dated lower left: "T. Stamos 46–47"
Titled verso: "Nautical Warrior"

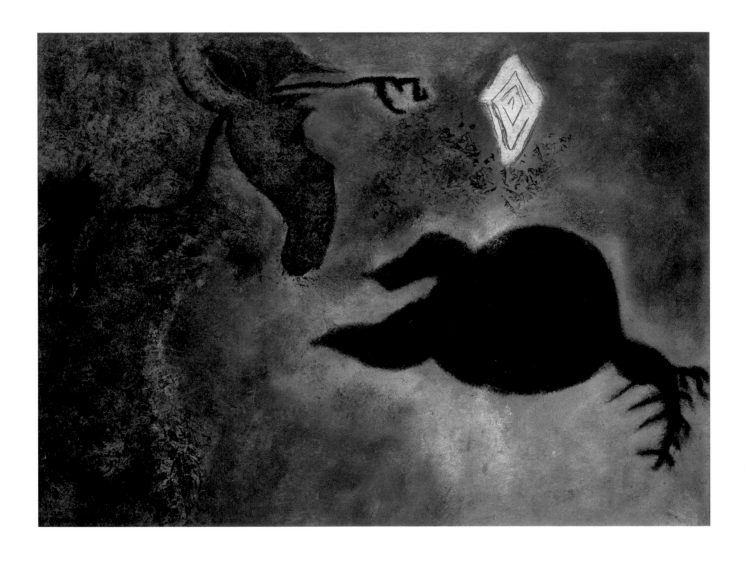

5

The Sacrifice, 1946
Oil on masonite, 29 x 38½ inches
Signed, dated, and inscribed lower left: "T. STAMOS '46, N.Y.C."
Signed and inscribed verso: "Theodoros Stamos, 237 W. 26th St., N.Y.C., USA"

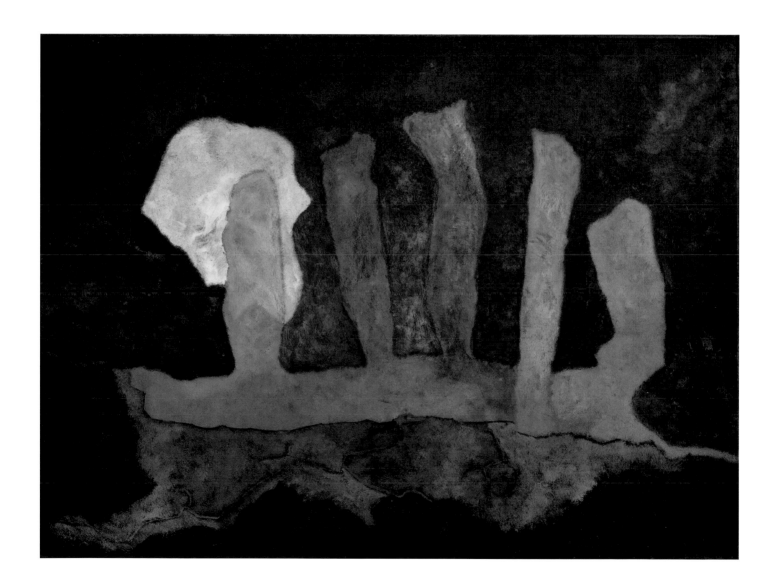

6

What the Wind Does, 1947
Oil on board, 10⅞ x 18¼ inches
Signed and dated lower left: "Stamos 1947"
Titled and signed verso: "'What the Wind Does' Stamos #35"

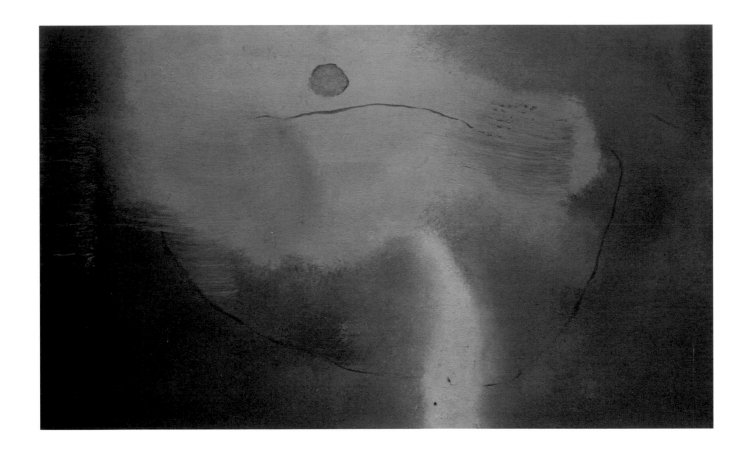

1

Ancient Land (TAO 810), 1947
Oil on masonite, 45 x 58 inches
Signed and dated lower left: "T. Stamos '47"
Signed, titled, and dated verso: "Stamos, ANCIENT LAND, 1947"

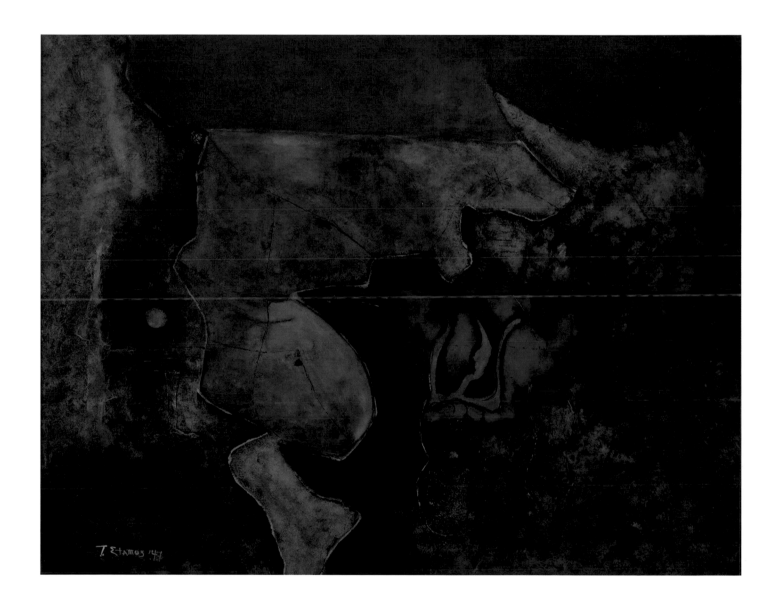

Migration, 1948
Oil on masonite, 36 x 48 inches
Signed and dated lower left: "T. STAMOS. '48"

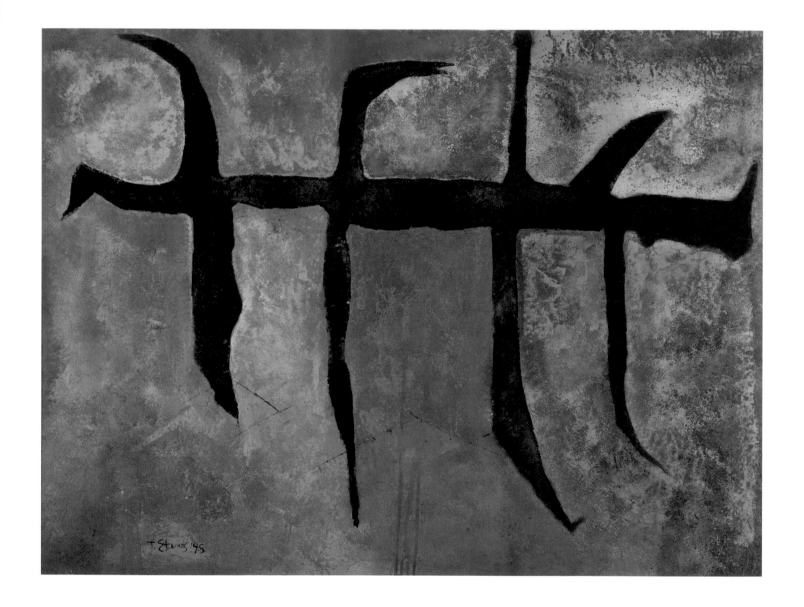

9

Flight of the Spectre, 1949
Oil on masonite, 29½ x 23¼ inches
Signed and dated lower left: "T. STAMOS '49"
Collection of Georgianna Stamatelos Savas

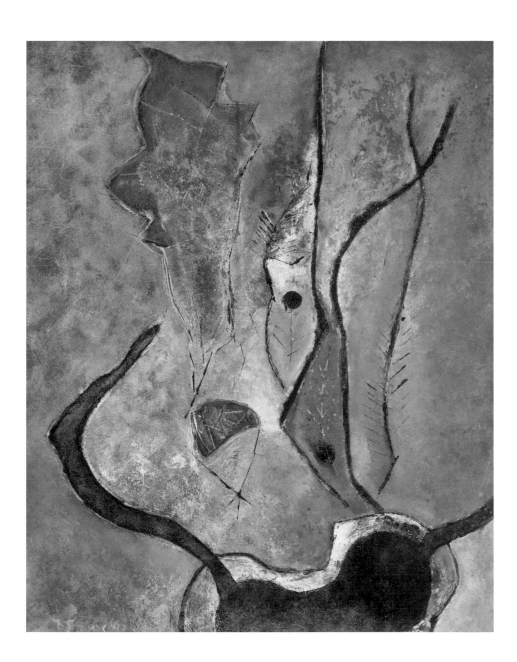

10
Untitled, 1950
Gouache on paper, 18 x 24 inches
Signed and dated lower left: "Stamos 1950"

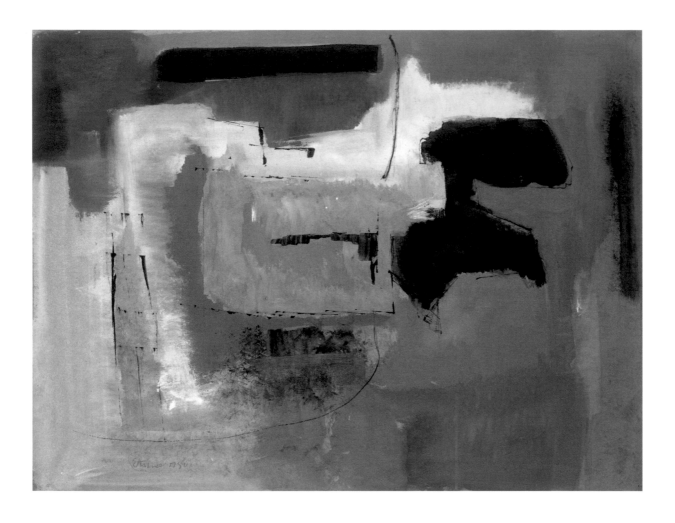

11

Old Egypt, circa 1952
Oil on canvas, 24½ x 39½ inches
Signed lower left: "Stamos"

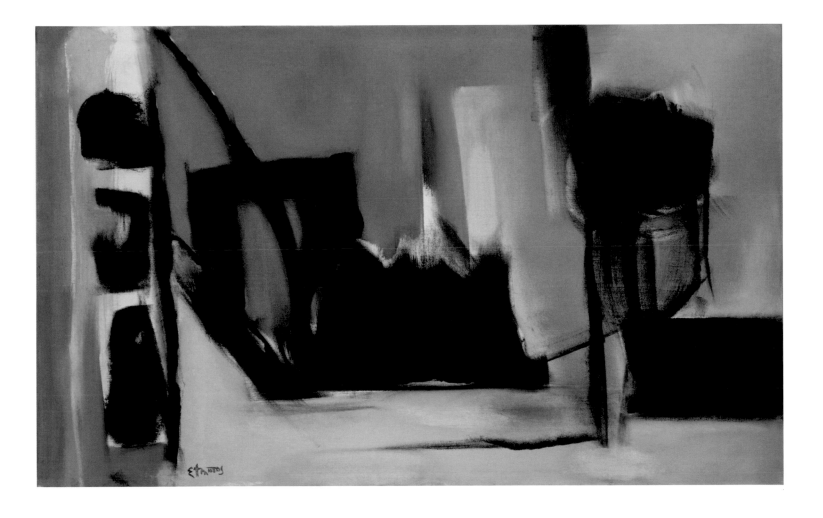

12

Delphic Shibboleth, 1959
Oil on canvas, 60 x 50 inches
Signed lower left: "STAMOS"
Signed, titled, and dated verso: "STAMOS, DELPHIC SHIBBOLETH, 1959"

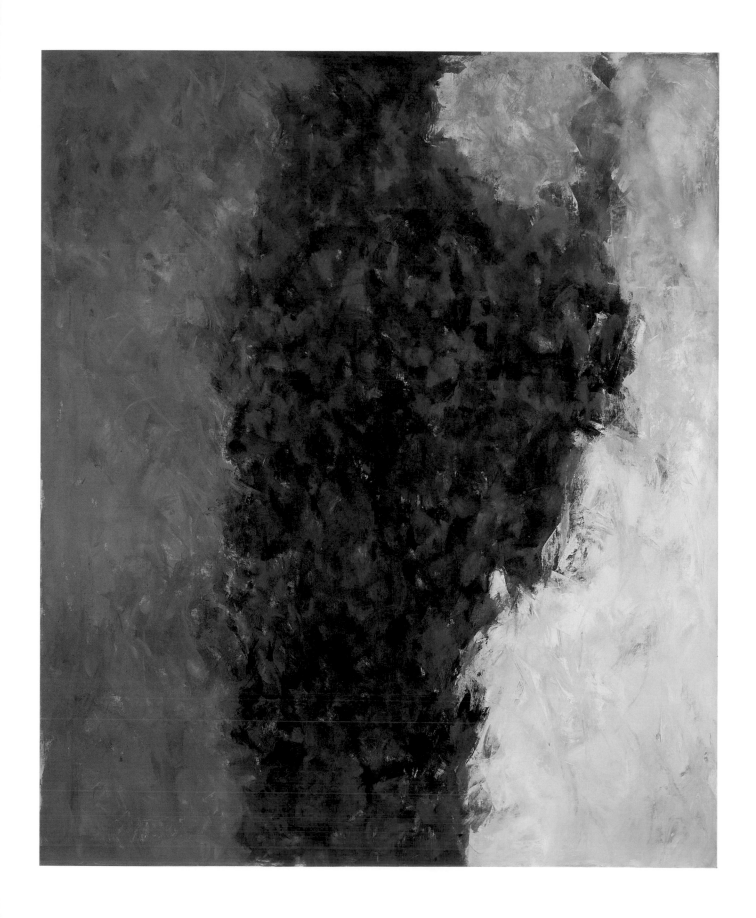

13

Deseret, 1959
Oil on canvas, 58 x 70 inches
Signed lower left: "Stamos"
Signed, titled, and dated verso: "Stamos, Deseret, 1959"

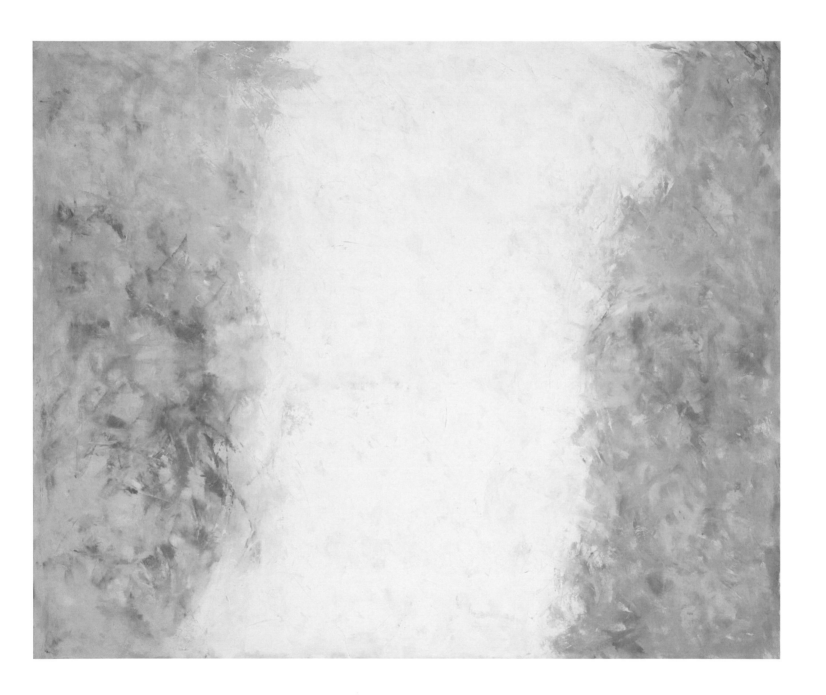

14

Sentinel III, 1960
Oil on canvas, 56 x 52 inches
Signed lower left: "Stamos"
Signed, titled, and dated verso: "Stamos, Sentinel III, 1960"

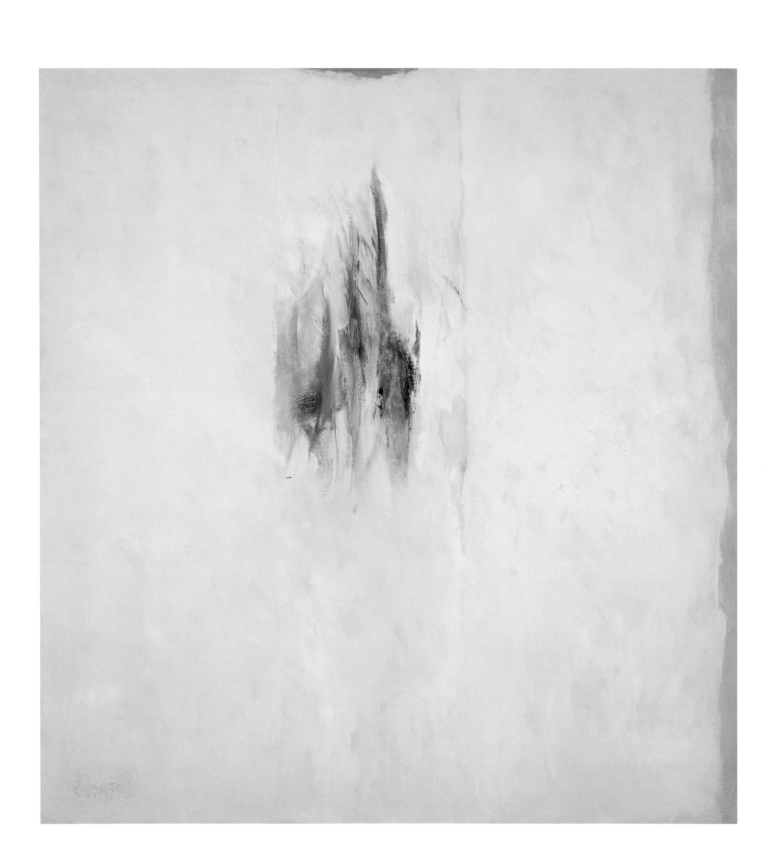

15

White Sun-Mound, 1963
Acrylic and oil on cotton, 68 x 56 inches
Titled and dated verso: "WHITE SUN-MOUND, 1963"

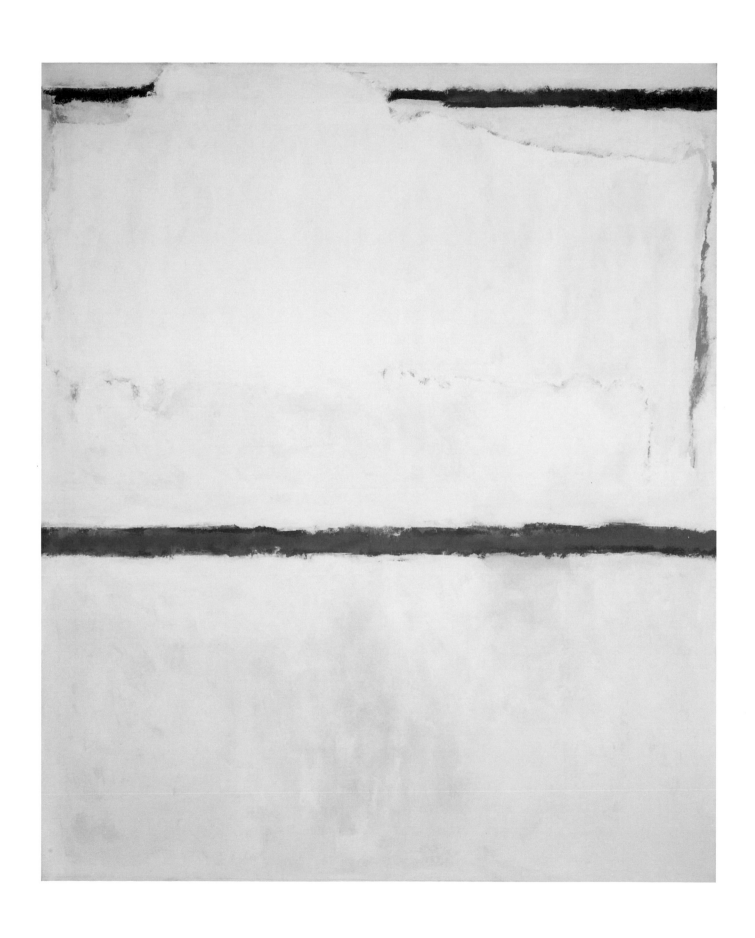

16
Olivet Sun-Box #II, 1967
Acrylic on canvas, 48 x 70 inches
Signed, titled, and dated verso: "Stamos, OLIVET SUN-BOX II, 1967"

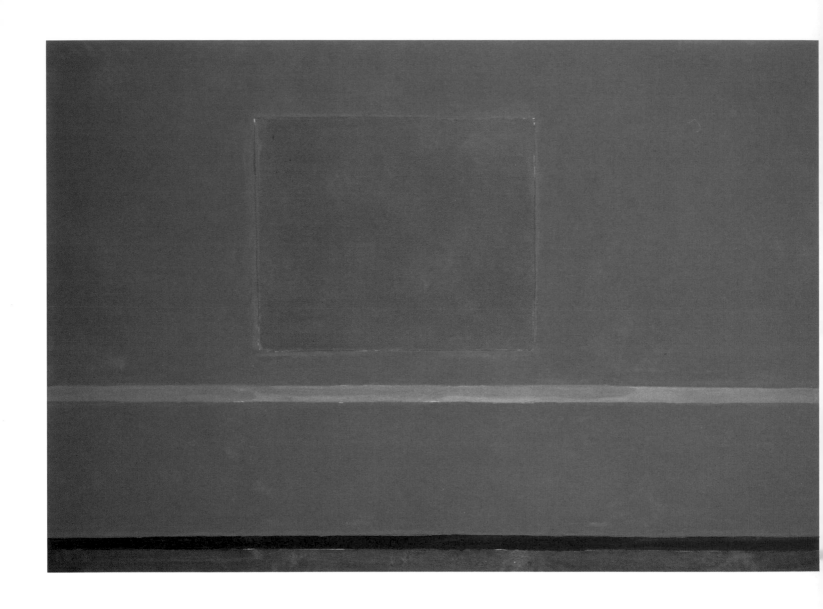

17
Delphic Sun-Box #2, 1968
Acrylic on canvas, 68 x 60 inches
Titled, dated, and signed verso: "DELPHIC SUN-BOX #2, 1968, Stamos"

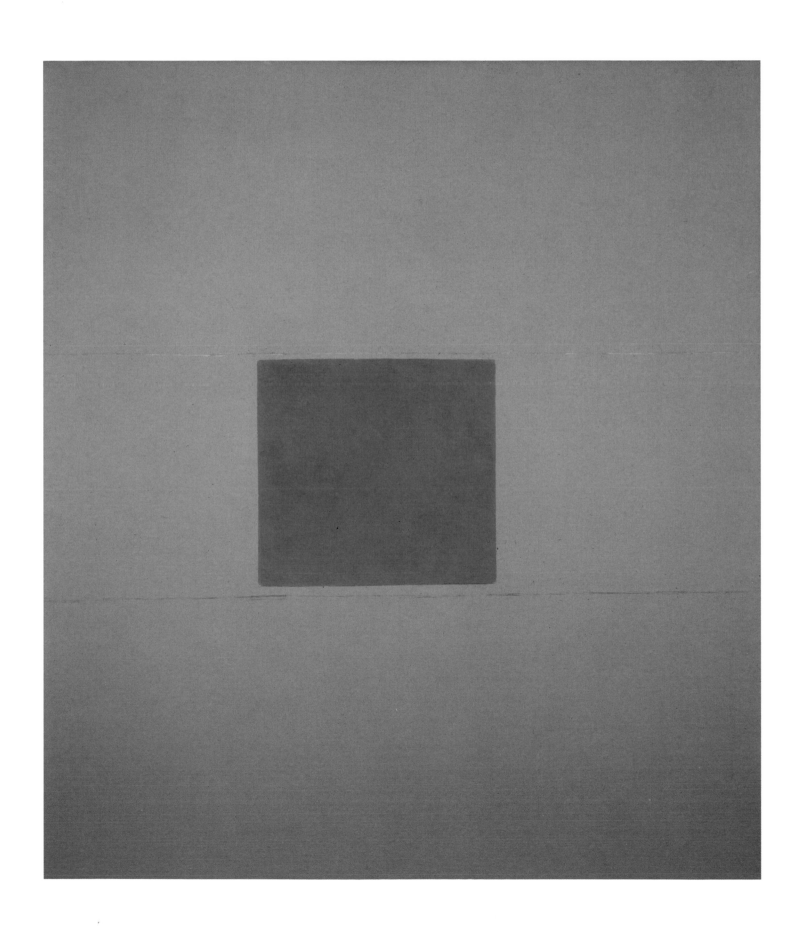

18
Classic Yellow Sun-Box, 1968
Acrylic on canvas, 36 x 48 inches
Signed, titled, and dated verso: "Stamos, CLASSIC YELLOW SUN-BOX, 1968"

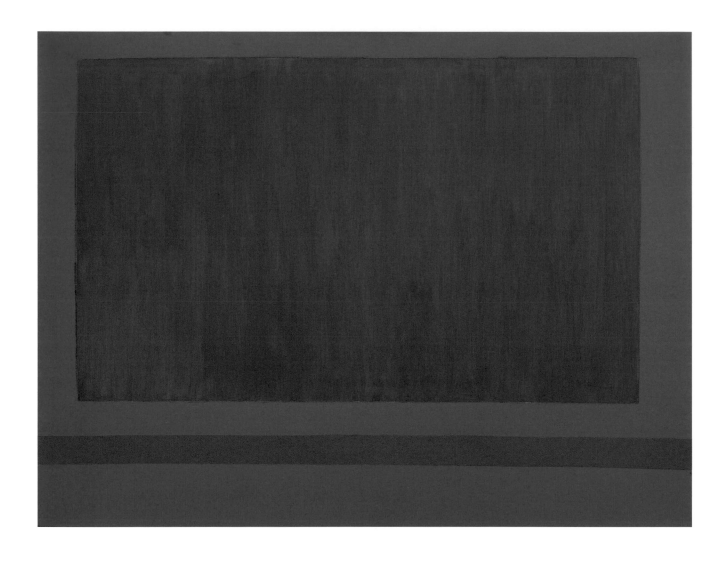

19

Homage to Milton Avery: Sun-Box III, 1969
Acrylic on canvas, 70 x 48 inches
Titled, dated, and signed verso: "HOMAGE TO MILTON AVERY, SUN-BOX III, 1969, STAMOS"

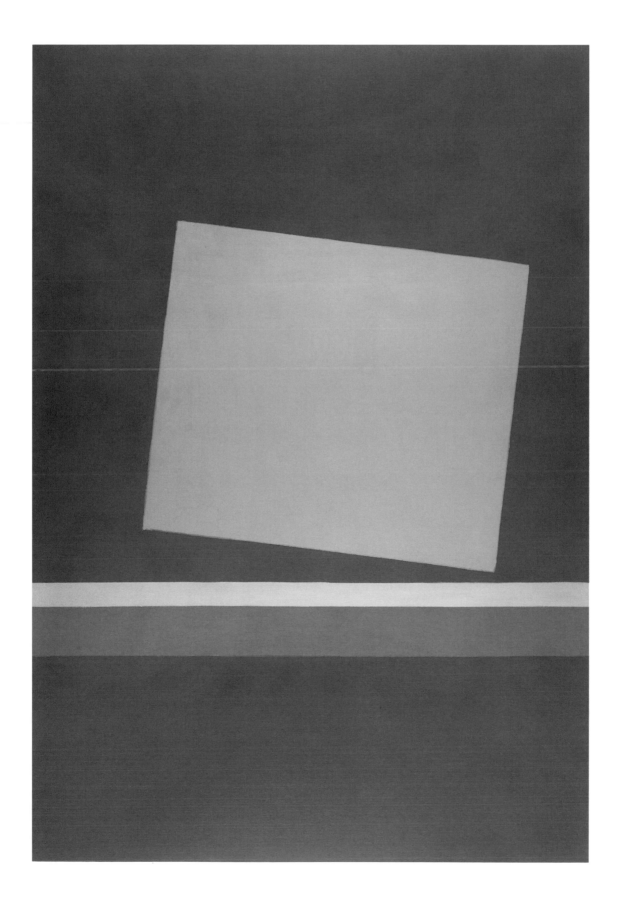

Infinity Field, 1970–71
Acrylic on canvas, 25 x 68 inches
Signed, titled, and dated verso: "STAMOS, INFINITY FIELD, 1970–1"

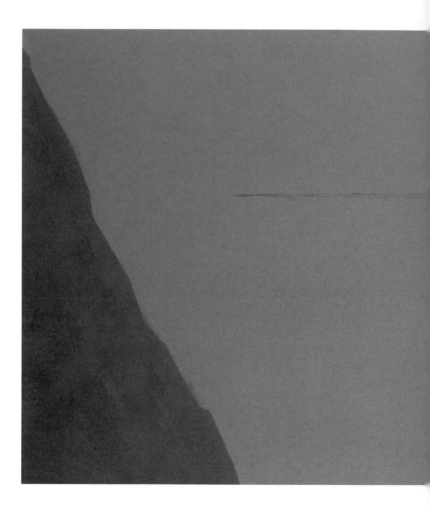

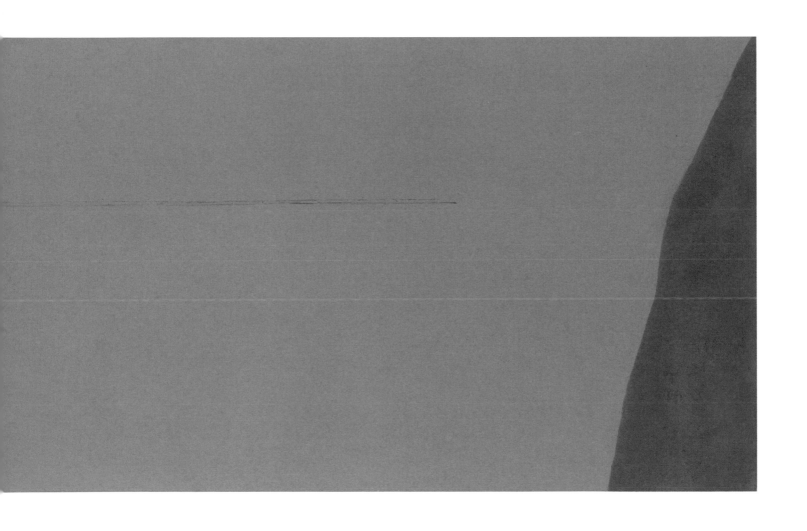

21

Transparent Green Sun-Box, 1970
Acrylic on canvas, 68 x 48 inches

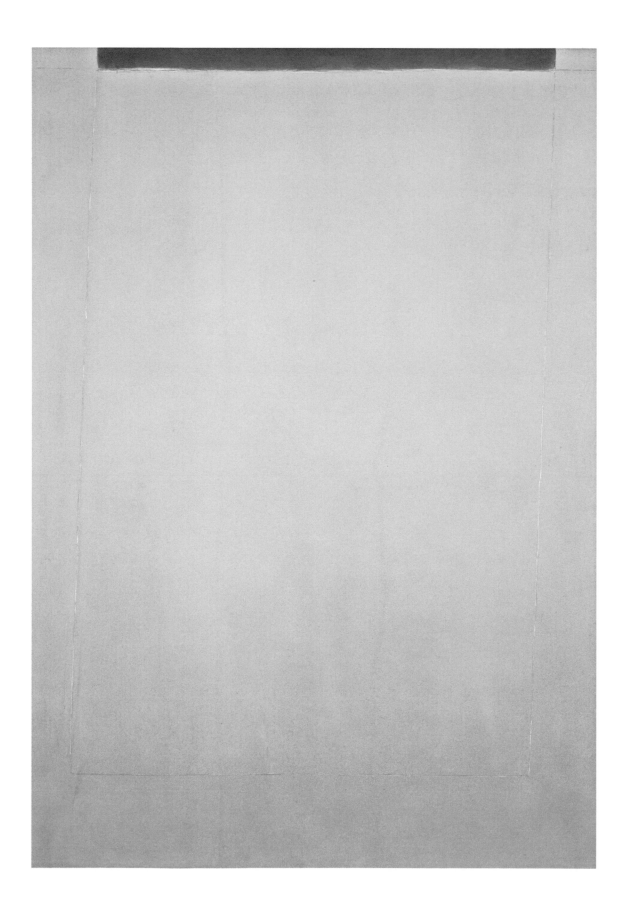

22
Infinity Field, Lefkada, 1971
Acrylic on canvas, 85 x 67 inches
Titled, dated, and signed verso: "INFINITY FIELD, LEFKADA, 1971, Stamos"

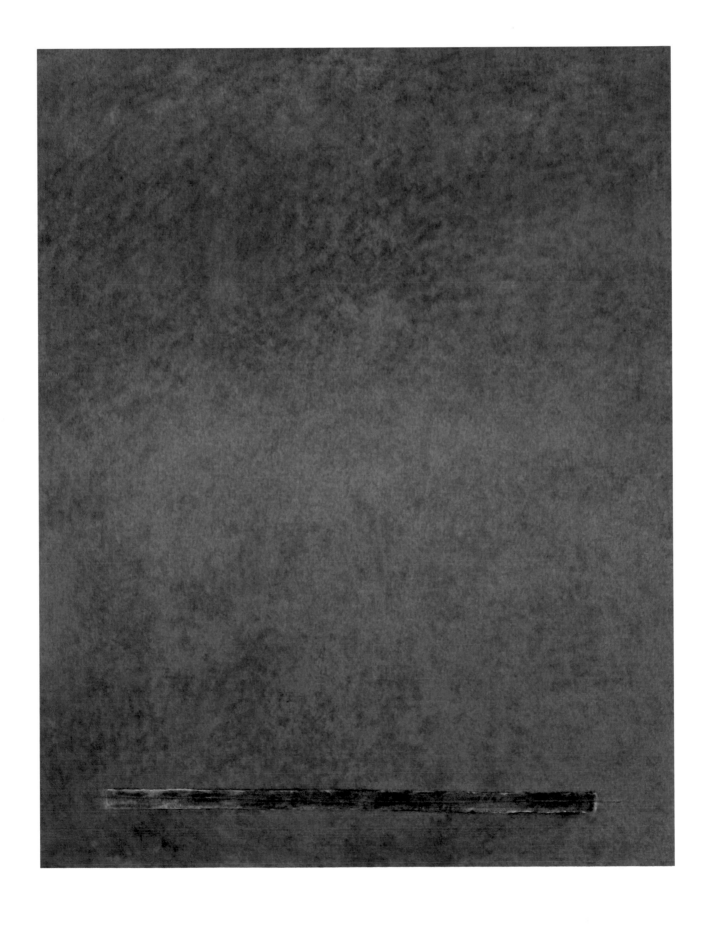

23

Infinity Field-Lefkada Series, 1972
Acrylic on canvas, 63½ x 105 inches
Titled, dated, and signed verso: "INFINITY FIELD, LEFKADA SERIES, 1972, t. stamos"

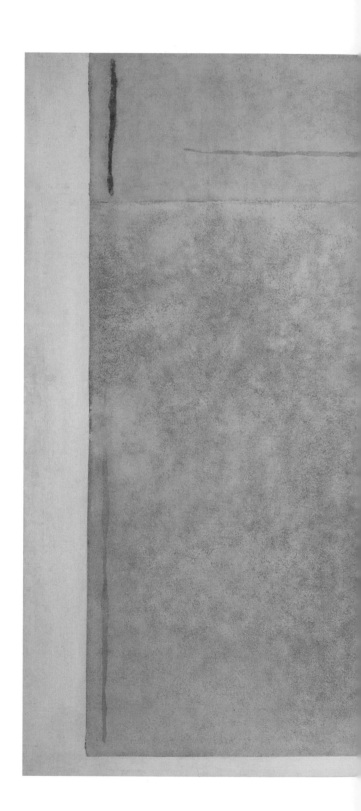

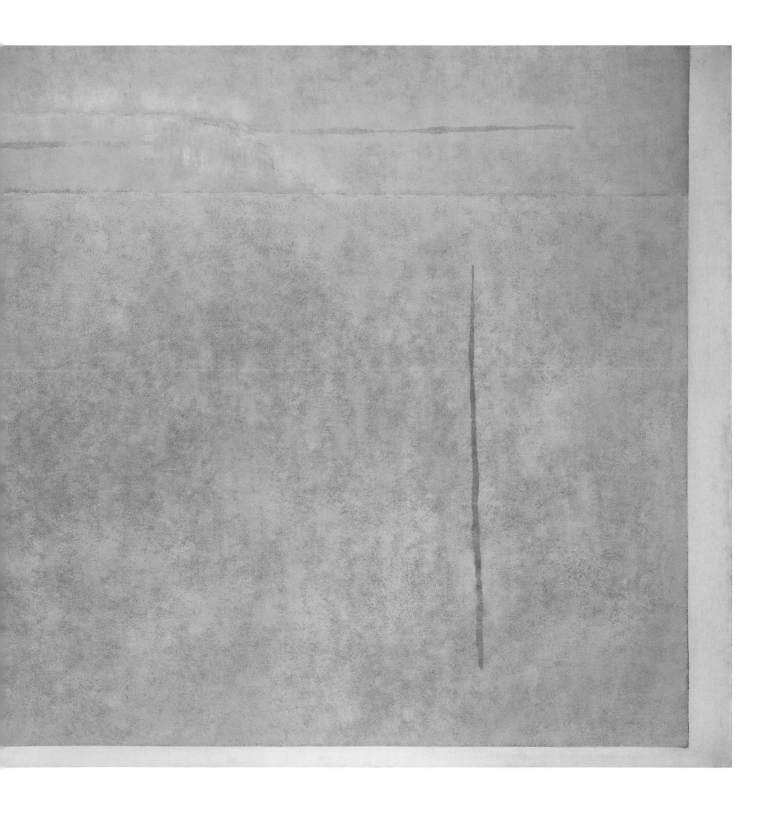

24

Infinity Field-Lefkada Series, 1973
Acrylic on canvas, 79 x 56 inches
Titled, dated, and signed verso: "INFINITY FIELD, LEFKADA SERIES, 1973, Stamos"

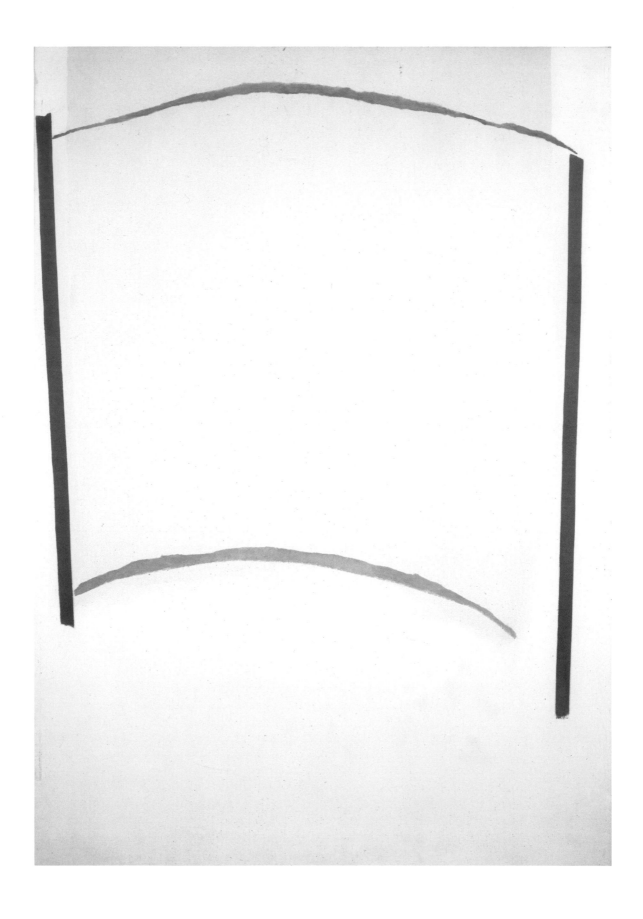

25

Infinity Field-Knossos, 1973–74
Acrylic on canvas, 90 x 48 inches
Titled and dated verso: "INFINITY FIELD, KNOSSOS, 1973–4"

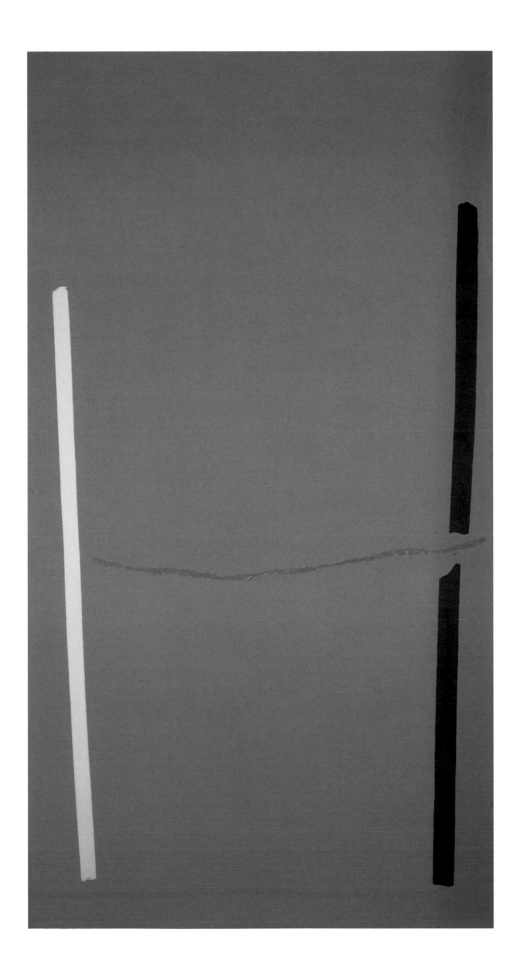

Infinity Field-Lefkada Series, 1977
Acrylic on canvas, 72⅛ x 59¾ inches

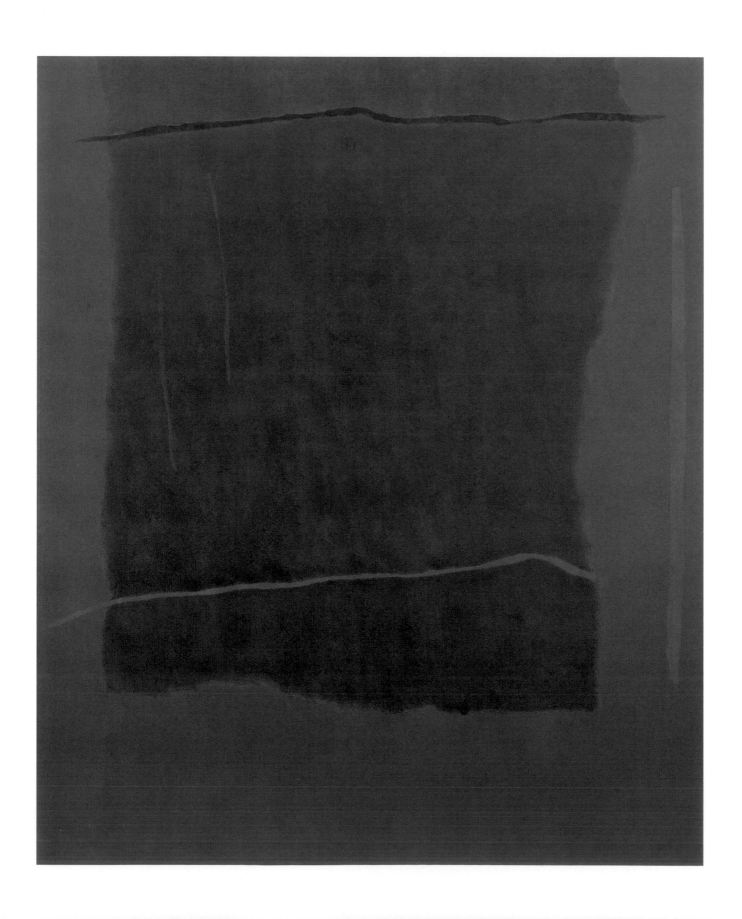

27
Infinity Field (HH/TS/7), 1978
Oil on canvas, 72 x 65½ inches
Signed and dated verso: "Stamos 1978"

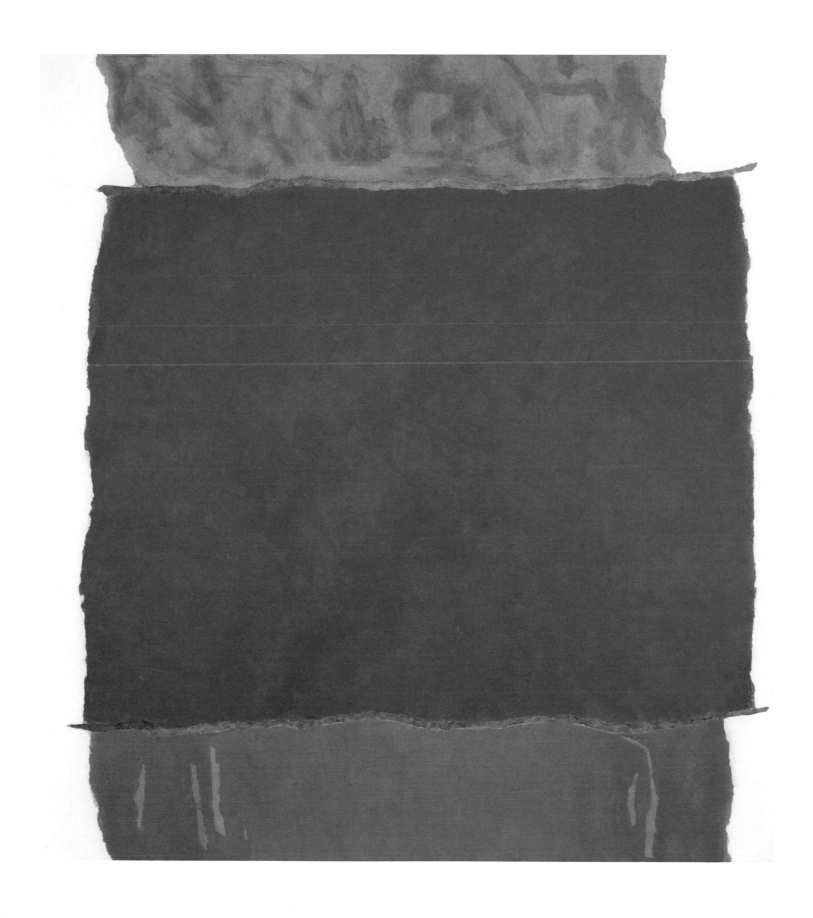

28

Infinity Field, Lefkada Series #2, 1978
Watercolor and gouache on paper, 30 x 22 inches
Signed, titled, and dated verso: "Stamos, Infinity Field,
Lefkada Series, 1978"

29

Infinity Field, Lefkada Series #3, 1978
Watercolor and gouache on paper, 30 x 22 inches
Signed, titled and dated verso: "Stamos,
Infinity Field, Lefkada Series #3, 1978"

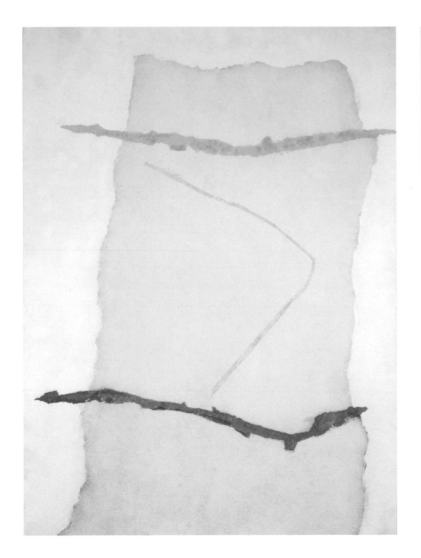

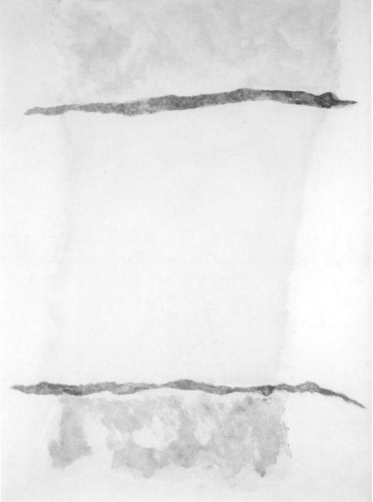

30

Infinity Field, Lefkada Series #11, 1978
Watercolor and gouache on paper, 22 x 30 inches
Signed, titled, and dated verso: "Stamos, Infinity Field, Lefkada Series, 1978"

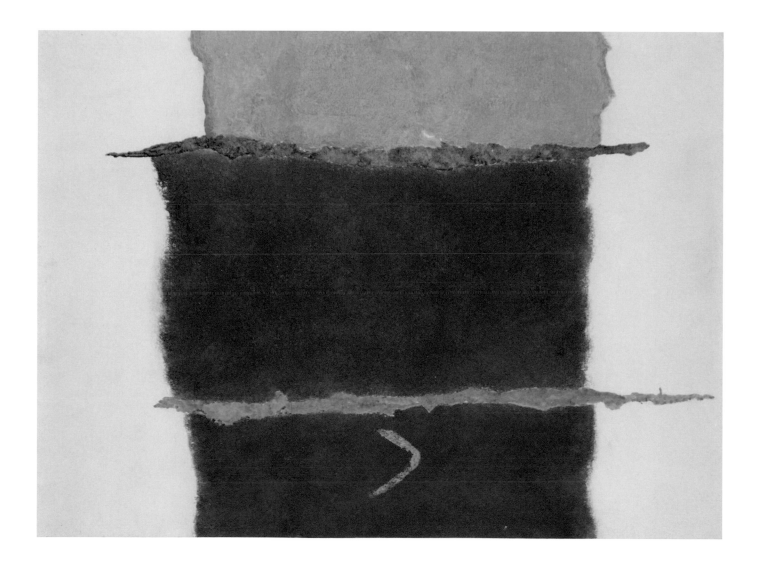

Infinity Field, Lefkada Series #5, 1978
Acrylic on paper, 30½ x 22¼ inches
Titled and dated verso: "Infinity Field, Lefkada Series #5, 1978"

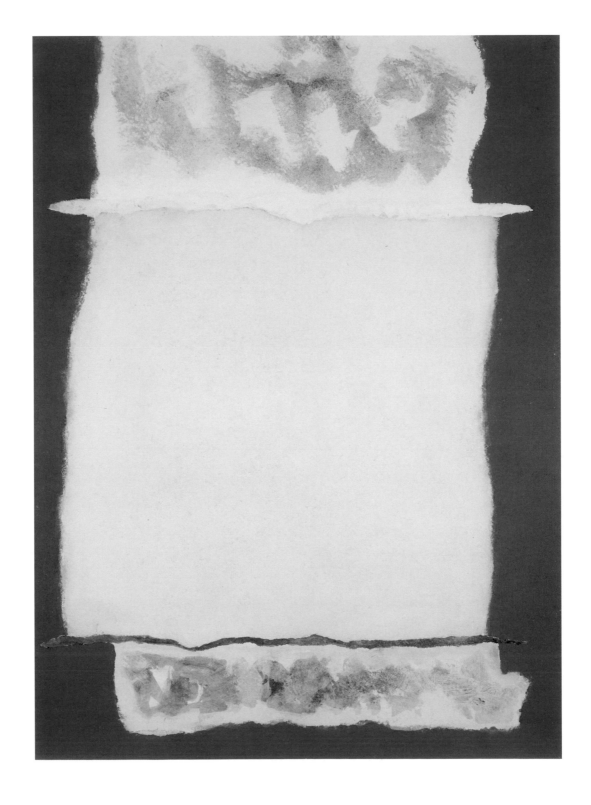

32

Infinity Field, Lefkada Series #8, 1978
Acrylic on paper, 22¼ x 30¼ inches
Signed, titled, and dated verso: "Stamos, Infinity Field, Lefkada Series #8, 1978"

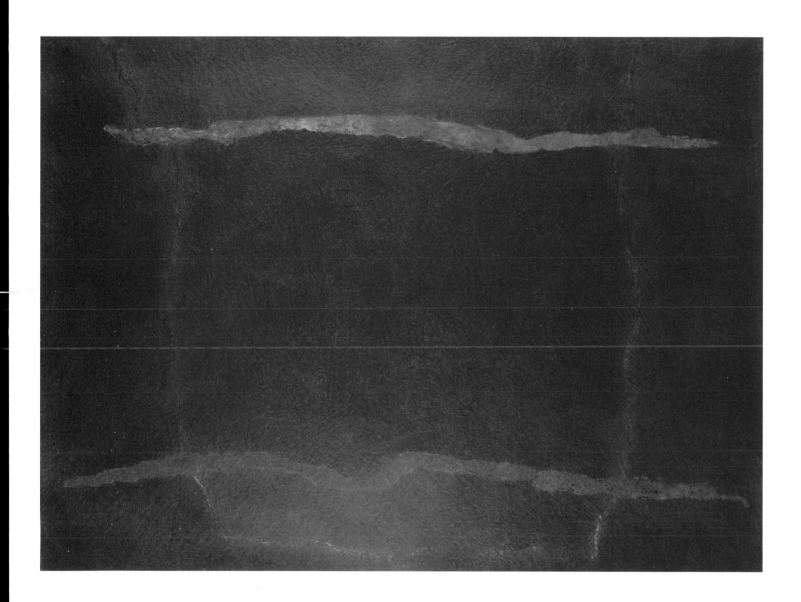

33

Infinity Field, Lefkada Series (For Niko Xylouris)—Triptych, 1982–83
Acrylic on canvas, 24 x 24 inches (each)

Left: Titled, dated, and inscribed: "'INFINITY FIELD, LEFKADA SERIES,' 1982–3
FOR NIKO XYLOURIS ('LAST WHITE MORNING'), #25, 62 x 61 см"

Center: Titled, dated, signed, and inscribed: "Infinity Field, Lefkada Series/
For Niko Xylouris/Ominous Noon/Stamos 1982–3, 30 x 30, #24, 62 x 61"

Right: Titled, dated, signed, and inscribed: "Infinity Field Lefkada Series
1982–3, Stamos/to/Niko Xylouris, 'White Night,' #26, 62 x 61 см"

These inscriptions refer to a distinguished musician from Crete popular
in the 1960s and 1970s who drew the censure of those who preferred
more traditional music.

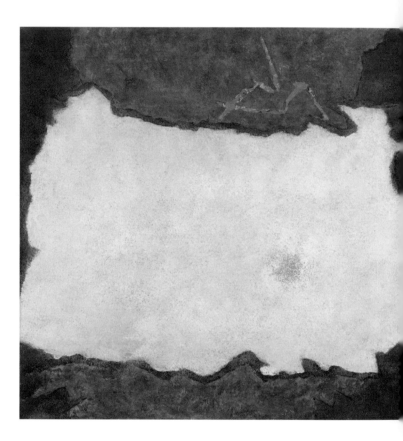

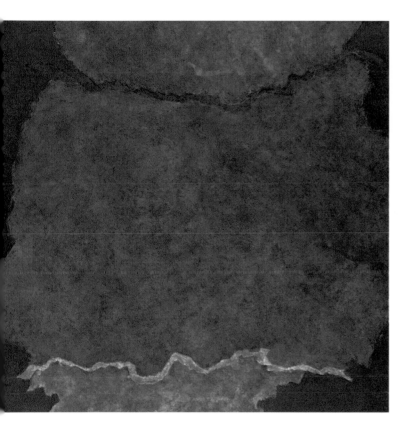 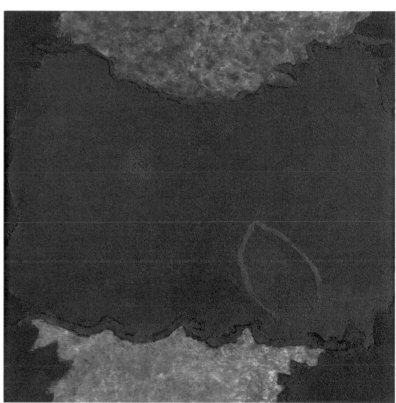

34

Infinity Field, 1982–83
Acrylic on canvas, 60 x 50 inches
Titled, inscribed, signed, and dated verso: "Infinity
Field, for C. D. Friedrich, Stamos, 1982–83"

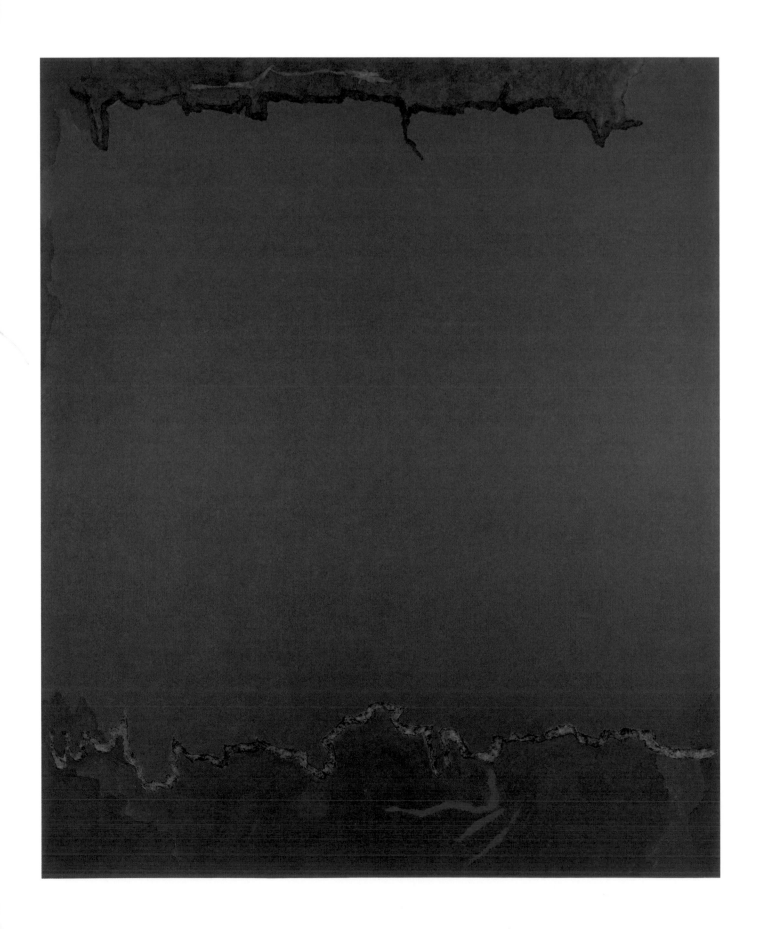

35
Infinity Field-Jerusalem Series, 1983–84
Acrylic on canvas, 56⅛ x 44⅛ inches
Titled, dated, and signed verso: "INFINITY FIELD JERUSALEM SERIES,
1983–84, Stamos"

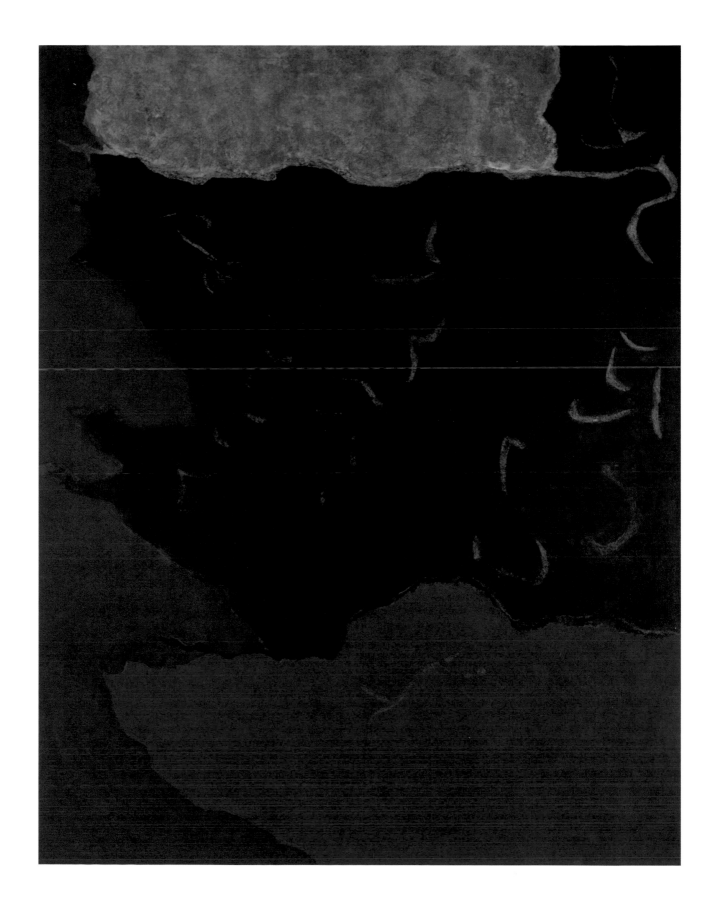

36
Infinity Field-Lefkada Series, 1983
Acrylic on paper, 30 x 22¾ inches
Titled, signed, and dated verso: "Infinity Field, Lefkada Series, Stamos, 1983"

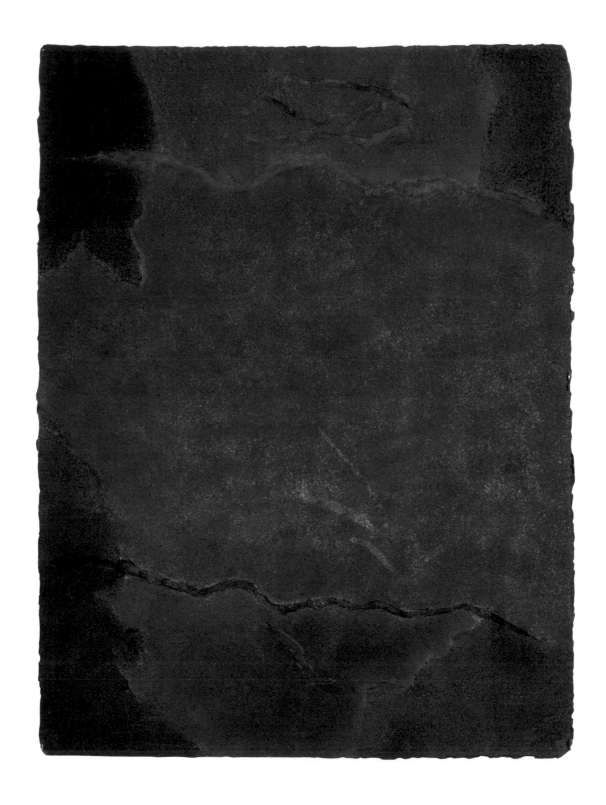

37

Infinity Field-Jerusalem Series, 1984
Acrylic on paper, 30 x 22¾ inches
Titled, signed, and dated verso: "Infinity Field, Jerusalem Series, Stamos, 1984"

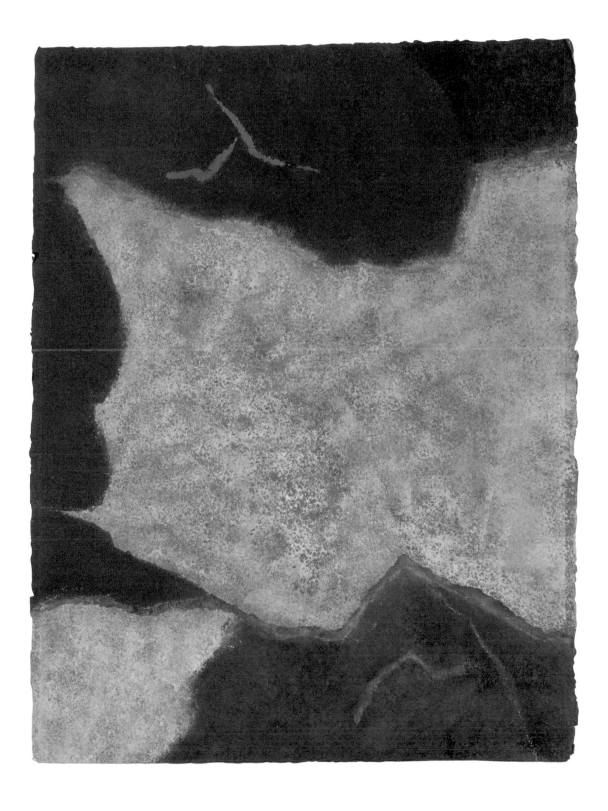

38

Edge of Burning Bush (A), 1986
Acrylic on canvas, 62 x 50 inches
Signed, titled, and dated verso: "Stamos, 'EDGE OF BURNING BUSH' A, 1986"

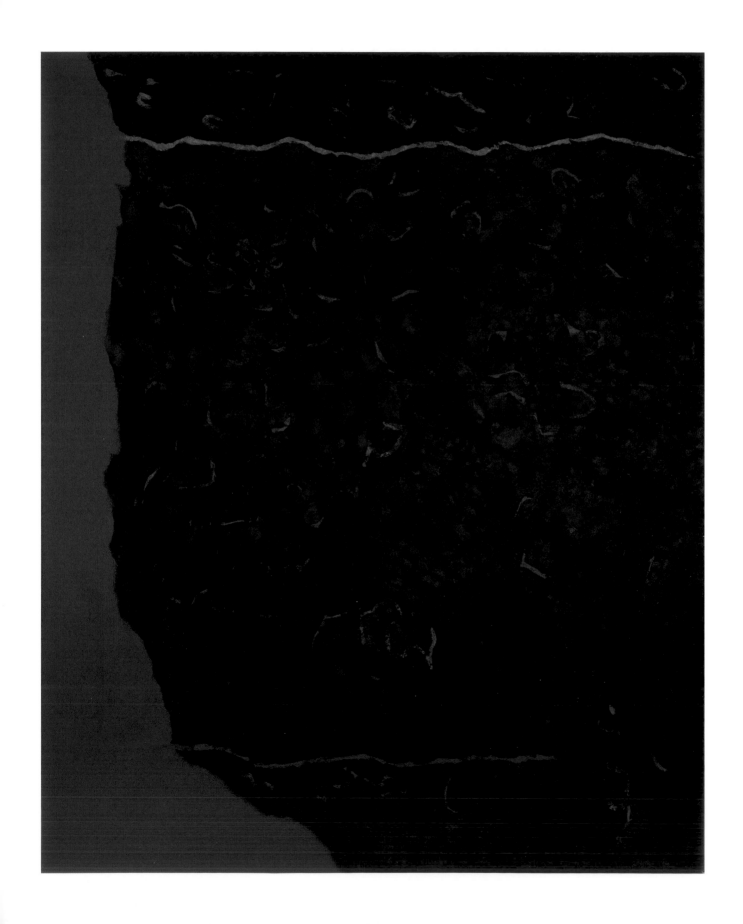

39

Infinity Field-Torino Series #7, 1986
Acrylic on canvas, 72 x 48 inches
Signed, titled, and dated verso: "Stamos, INFINITY FIELD-TORINO SERIES #7, 1986"

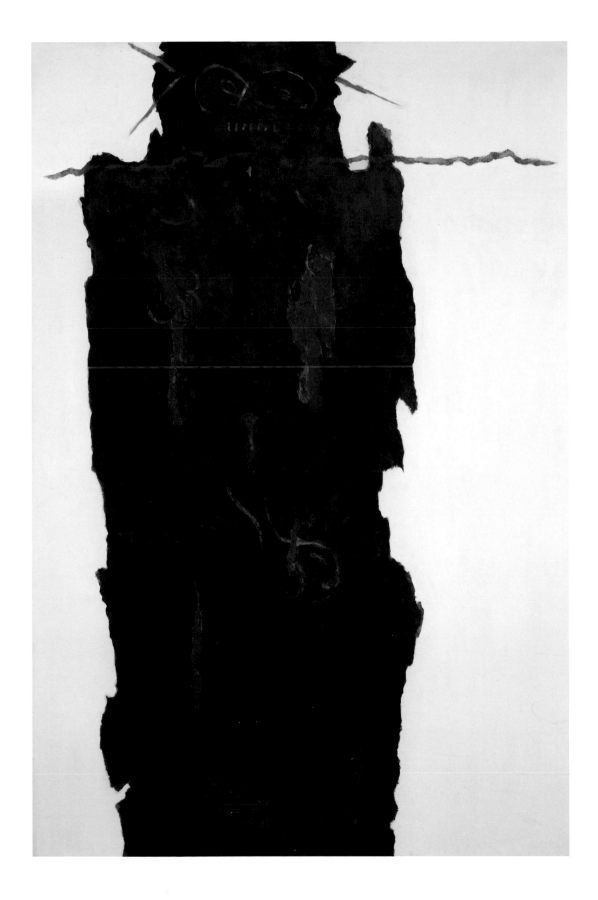

Infinity Field JS #2, 1992
Acrylic on canvas, 60 x 50 inches
Titled, dated, and signed verso: "'INFINITY FIELD, J SEIRS,' #2, 1992, STAMOS"
Collection of Prof. Athena Lazarides Demetrios

Let us all know that art is not an adjunct to existence, a reduplication of the actual. It is a hint and at the same time a promise of the perfect rhythm, the ideal life. Theodoros Stamos, "Why Nature in Art"

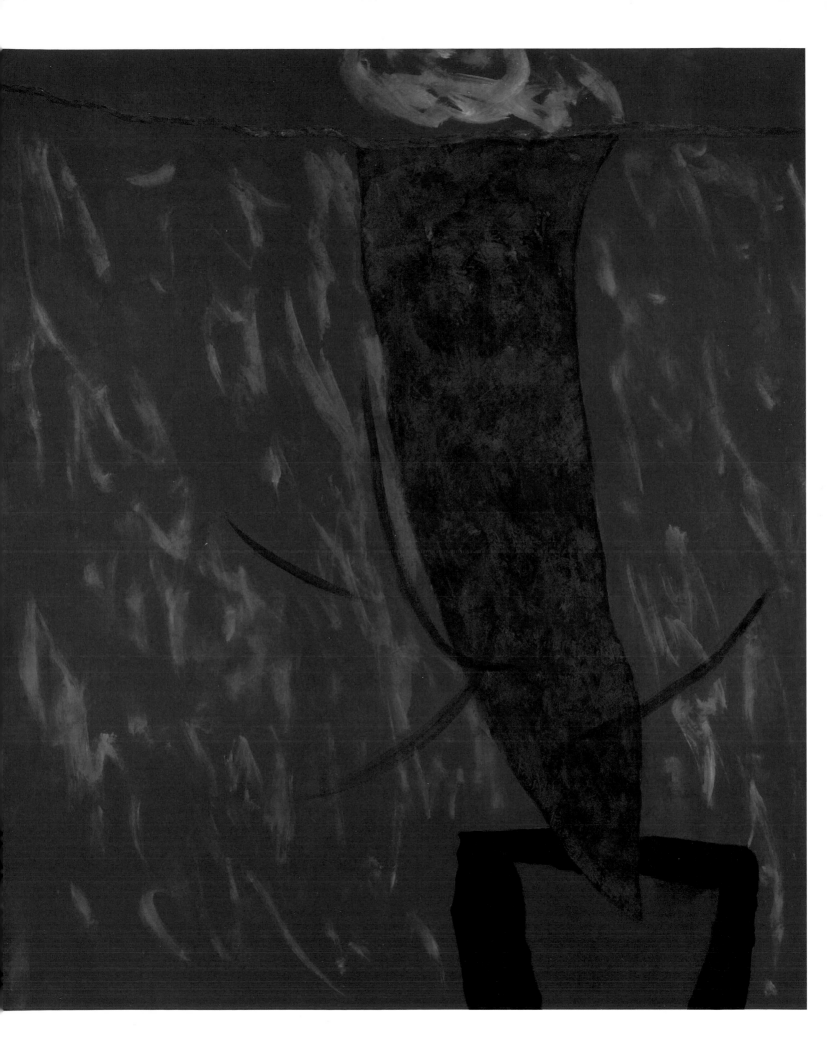

1922 Born December 31 in Manhattan to Theodoros and Stamata Stamatelos, Greek immigrants who run a hat-cleaning and shoeshine shop off St. Mark's Place in Lower Manhattan. The fourth of six children, he will later adopt "Stamos" as his surname, but he will never legally change it.

1930 After a fall results in a ruptured spleen, takes up drawing and sculpture. Is hospitalized for approximately three months.

1936 Begins attending Peter Stuyvesant High School and earns a scholarship to the American Artists School on West Fourteenth Street in New York, where he studies sculpture at night. His sculpture teachers include Simon Kennedy and Joseph Konzal. Stamos never studies painting formally. Develops an avid interest in reading.

1937 Joseph Solman, a member of The Ten (along with Mark Rothko and Adolph Gottlieb) and a teacher at the American Artists School, encourages him to begin painting. Visits contemporary art galleries, including Knoedler & Company, Buchholz Gallery, and Alfred Stieglitz's An American Place. Is particularly interested in the work of Arthur Dove.

1939 Leaves Peter Stuyvesant High School three months before he would have graduated to focus on painting. Takes odd jobs, including frame maker, florist, prism maker, printer, caster, and book salesman.

1940 Introduced to Milton Avery by Joseph Solman.

1941 Begins managing a frame shop owned by Herbert Benevy on East Eighteenth Street and will work there until 1948. At the shop, a popular artists' meeting place, makes the acquaintance of Arshile Gorky and Fernand Léger, among other artists. For Nierendorf Gallery, frames numerous paintings by Paul Klee.

Does not serve in World War II; spleen operation renders him unfit to serve, and he is given 4F status.

1943 Meets Betty Parsons, who gives Stamos his first solo exhibition at age twenty at her Wakefield Gallery and Bookstore. He will show with her nearly every year through 1956. Introduced to Adolph Gottlieb and Barnett Newman. Jackson Pollock has his first one-man exhibit at Peggy Guggenheim's Art of This Century gallery this same year.

1944 Develops an interest in Surrealism by visiting galleries, including Julien Levy and Pierre Matisse, and reading Surrealist publications, such as the journal *VVV*. Explores a biomorphic idiom that incorporates primordial and mythological themes. Has solo exhibition at Mortimer Brandt Gallery, where he will show regularly during the next few years.

1945 Is included in the "Annual Exhibition of Contemporary American Painting" at the Whitney Museum of American Art, the first of numerous exhibitions at the museum. Edward Root purchases his painting *Movement of Plants,* which was in Whitney show. Root will become an important patron and will own thirty-two pieces by Stamos. Participates in a group show organized by Betty Parsons at Mortimer Brandt Gallery, in which work by John Graham and Hedda Stern is also exhibited. Also exhibits in a group show at Betty Parsons that includes work by Jackson Pollock, Barnett Newman, and Clyfford Still.

1946 Museum of Modern Art acquires *Sounds in the Rock*, a gift from Edward W. Root. It is his first painting to enter a museum collection. Meets Clyfford Still. Has solo exhibition at Mortimer Brandt Gallery.

Meets Peggy Guggenheim, Mark Rothko, Tony Smith, and John Graham. Reads Graham's *Systems and Dialectics*. Travels by train through the United States, stopping in New Mexico, California, and the Pacific Northwest. Meets and exchanges pictures with Mark Tobey in Seattle. Also seeks out Morris Graves on this trip. Makes first trip to Provincetown, Mass.

Has solo show at Betty Parsons Gallery; Barnett Newman writes the catalogue essay. Is also included in "The Ideographic Picture" at Betty Parsons Gallery, an important early group show of Abstract Expressionist work curated by Newman, which includes work by Rothko and Hans Hofmann. Creates Good Friday series, a response to the death of his uncle at the hands of Greek guerillas on Good Friday of that year. Commissioned to paint mural for cruise ship SS *Argentina*.

Statement by Stamos and two paintings (*Ancestral Shore* and *Ancestral Construction*) reproduced in December issue of avant-garde journal *The Tiger's Eye*. Stamos is the subject of article "Abstracting the Ocean" by Thomas Hess in February issue of *Art News*, and *Sounds in the Rock* is reproduced in an article on modern art in *Life* magazine's October issue.

1948 Work is included in his first exhibition at Museum of Modern Art. Solo exhibition at Margaret Brown Gallery, Boston.

1948–49 Travels to Europe with close friend, poet Robert Price. Visits France, Italy, and Greece. Is in Greece during the country's civil war. In Paris, is influenced by Monet and Watteau; in Italy, sees work by Tiepolo. Meets many European modernists, including Brancusi, Giacometti, and Picasso. Visits Egypt, possibly during this period.

1949 Begins Teahouse series, which is heavily influenced by Asian art.

1950 Has first solo museum exhibition at The Phillips Collection, Washington, D.C. Begins teaching at the Hartley Settlement House in New York, where he will work for the next four years. Takes summer teaching position at Black Mountain College, North Carolina. Kenneth Noland is one of his students, and critic Clement Greenberg is also in residence. Solo show at Margaret Brown Gallery. Is identified as one of "Nineteen Young American Artists" in *Life* magazine's March issue.

1951 Nina Leen's famed photograph of "The Irascibles" appears in January issue of *Life* magazine, picturing the leading Abstract Expressionist painters, including Willem de Kooning, Robert Motherwell, Barnett Newman, Jackson Pollock, Mark Rothko, Richard Pousette-Dart, and Stamos, the youngest of the group.

Awarded Louis Comfort Tiffany Foundation Fellowship. Illustrates book of poetry, *The Sorrows of Cold Stone: Poems 1940-1950*, by John Malcolm Brinnin. Moves to a house designed for him by sculptor Tony Smith on the water in East Marion, New York, where he will spend much of his time for the next decade.

1953 Takes summer teaching job at the Bennington School of the Arts in Vermont and is included in a group show there. Included in the Metropolitan Museum of Art's exhibition of the Edward Root collection. His work also shown in exhibitions at the Brooklyn Museum and the Cranbrook Academy of Art. Whitney Museum purchases *Greek Orison*.

1954 Delivers his influential "Why Nature in Art?" lecture at The Phillips Collection in Washington, D.C. During the next few years, will deliver the lecture at institutions including the Art Institute of Chicago, the Munson-Williams-Proctor Institute, Bennington College, Hunter College, Tulane University, Virginia Museum of Fine Arts, the Memphis Academy of Arts, and the University of Alabama. Stays with Duncan Phillips in Washington and has solo exhibition at the Phillips Collection. Meets Robert Motherwell. Grieves over unexpected death of his friend Robert Price.

1955 Begins teaching at the Art Students League, New York City, where he will work for several years. Solo exhibition a the DeCordova and Dana Museum, Lincoln, Mass. Work is included in Whitney Museum's "The New Decade: 35 American Painters and Sculptors," which travels nationally. Metropolitan Museum of Art purchases *In Memoriam.*

1956 Illustrates book of poems by Robert Price, *The Hidden Airdrome*, published posthumously. Has last show at Betty Parsons Gallery and is awarded National Institute of Arts and Letters Award.

1957 Begins High Snow–Low Sun series. Solo exhibitions at Philadelphia Arts Alliance; Gump's Gallery, San Francisco; and Michigan State University, East Lansing.

1958 Has solo show at André Emmerich Gallery, the first of many. A mid-career retrospective is organized by The Corcoran Gallery of Art, Washington, D.C. Two major traveling exhibitions include his work: the Museum of Modern Art's "The New American Painting," a world-traveling exhibition highlighting Abstract Expressionism, and the Whitney's "Nature in Abstraction" exhibition, which travels around the United States.

1959 Accepts Brandeis Creative Arts Award and included in "II. Documenta '59" in Kassel, Germany. Contributes statement to *It Is* magazine.

1960 Work exhibited in London at Gimpel Fils and in San Antonio at the Marion Koogler MacNay Art Institute. Kenneth B. Sawyer's monograph on Stamos published in Paris by Editions Georges Fall.

1961 Sells East Marion home and buys a townhouse on West 83rd Street in Manhattan. Solo show at Galleria del Naviglio in Milan.

1962 Begins series of Sun-Box paintings, with enormous, expanding shapes that almost fill the surface of his canvases. Participates in the Whitney's "Forty Artists Under Forty" exhibition, which travels nationally.

1963 Begins working with acrylic paint.

1964 Creates first lithograph.

1966 Starts guest lecturing at Columbia University's School of Fine Arts.

1967 Receives National Arts Foundation Award and becomes third annual Maurice and Shirley Saltzman Artist-in-Residence at Brandeis University, succeeding Jacob Lawrence and Philip Guston in the position. Has solo exhibition at the university. Stamos' father dies on November 28. Friendship with Rothko deepens.

1968 André Emmerich Gallery exhibits series of blue pictures painted in his father's memory. Included in Museum of Modern Art's "Dada, Surrealism, and Their Heritage" exhibition, which travels to the Art Institute of Chicago and the Los Angeles County Museum of Art.

Shows work in Montreal at Waddington Fine Arts. Works in collage to create tapestry designs; exhibits in "American Tapestries" at Charles E. Slatkin Galleries in New York.

1969 Large-scale tapestry commission completed for a Manhattan office building at 150 East 58th Street.

1970 Eighteen paintings shown at André Emmerich Gallery.

Rothko commits suicide on February 25. Accepting Stamos' offer, Rothko family buries him in the Stamos family plot at East Marion. Stamos supervises the posthumous installation of Rothko's paintings at the Rothko Chapel in Houston. Along with Bernard Reis, director of Marlborough Gallery, and anthropology professor Morton Levine, Stamos is named executor of Rothko estate. Travels to Lefkada, his father's native island in Greece. Will spend a portion of each year there from this point on. In Lefkada, begins work on the Infinity Field paintings, a major project that he will pursue over the next twenty years.

1971 Participates in group show at the Whitney Museum of American Art, "Structure of Color."

In November, Rothko's daughter's guardian charges the estate's three executors with conspiracy and conflict of interest.

1972 Solo show at Marlborough Gallery. Builds a studio in Lefkas, Greece.

1973 Joslyn Art Museum, Omaha, Nebraska, organizes solo exhibition.

1974 The Athens Gallery organizes first solo show in Greece. Rothko trial begins on 14 February. Ralph Pomeroy's important monograph *Stamos* published by Abrams.

1975 Gives 34 paintings to the National Gallery and Alexandros Soutzos Museum in Athens. Contributes to "Subject of the Artists" exhibition at the Whitney Museum of American Art. Court finds Rothko estate's executors guilty of negligence.

Executors of Rothko estate reach a settlement. Having never profited from a Rothko painting, Stamos maintains innocence. Solo exhibitions at Galerie Le Portail, Heidelberg, Germany; Louis K. Meisel Gallery, New York; and Morgan Gallery in Shawnee Mission, Kansas.

1978 Work is subject of one-man shows at the Tomasulo Gallery at Union College, New Jersey; Hokin Gallery in Palm Beach, Florida; Louis K. Meisel Gallery, New York; and at the National Gallery and Alexandros Soutzos Museum, Athens.

Has solo exhibitions at Edwin A. Ulrich Museum, Wichita State University, Kansas; Louis K. Meisel Gallery, New York; and Stamford Museum, Connecticut.

Devotes a group of his Infinity Field paintings to nineteenth-century German artist Caspar David Friedrich. Has solo shows at Munson-Williams-Proctor Institute, Utica, New York; State University College, New Paltz, New York; Books and Company, New York; Turske Fine Art, Cologne; and Hokin Gallery, Chicago.

Solo exhibitions at Turske Fine Art, Zurich, and Louis K. Meisel Gallery.

Has solo show at Jean & Karen Bernier Gallery in Athens.

1983 Travels to Jerusalem with cousin Theodosis Stamatelos and introduces new symbolism, including calligraphic writing and deep reds, into Infinity Fields. Solo exhibition at M. Knoedler in Zurich. Completes murals for office building in Cologne.

1984 Has a 1945–1984 retrospective at M. Knoedler, Zurich, and a solo show at Kouros Gallery in New York.

Exhibits at Kouros Gallery and Ericson Gallery in New York; Turske & Turske, Zurich; Galerie Würthle, Vienna; C. Grimaldis Gallery, Baltimore; and Harcourts Contemporary in San Francisco.

Solo shows at Honkin Gallery, Palm Beach, Florida; Kouros Gallery, New York; Harcourts Contemporary, San Francisco; and C. Grimaldis Gallery, Baltimore.

1987 One-person exhibitions at Museum Morsbroich in Leverkusen, Germany; Kouros Gallery, New York; Turske & Turske, Zurich; and Pierides Gallery of Modern Art, Athens.

1988 Shows Infinity Fields paintings at Jack Rutberg Fine Arts, Los Angeles, and Kouros Gallery, New York. Also receives one-person shows at Dorsky Gallery, New York; C. Grimaldis Gallery, Baltimore; Studio d'Art Zanussi, Milan; and Pascal de Sarthe Gallery, San Francisco.

1989 Has solo exhibitions at Kouros Gallery, Dorsky Gallery, and Louis K. Meisel Gallery in New York; and Ileana Tounta Contemporary Art Center in Athens.

Is subject of retrospective at ACA Gallery in New York and solo exhibitions at Luthi & Luthi Gallery in Kruverlingen, Switzerland; Louis Newman Galleries, Beverly Hills; and Louis K. Meisel and Kouros Galleries, New York.

1992 Has a second retrospective at ACA Gallery in New York and a solo show at Ileana Tounta Contemporary Art Center in Athens. Suffers a serious stroke.

Creates his last painting, which remains unfinished. Has his last show at the Ileana Tounta Contemporary Art Center in Athens and a retrospective at the Thessaloniki Municipal Art Gallery. Solo exhibition at Kouros Gallery, New York.

Exhibits at Northern Westchester Center for the Arts, Mt. Kisco, New York.

1996 Has solo shows at Hiro Gallery, Tokyo, and Kouros Gallery, New York.

1997 After hospitalization for a lung ailment, Stamos dies on February 2 in Yannina, Greece. He is buried in Lefkada. Major retrospective opens in September at National Gallery and Alexandros Soutzos Museum, Athens.

The Green Sky, 1944
Oil on masonite, 23¹⁵/₁₆ x 29¹⁵/₁₆ inches
Signed and dated lower left: "T. STAMOS '44"
Signed, titled, and dated verso: "STAMOS
'Green Sky' 1944"
Collection of John and Denise Ward
(Plate 1)

Undersea Fantasy, 1945
Oil on board, 14 x 20 inches
Signed, dated, and inscribed lower left:
"T. Stamos '45 N.Y.C."
Inscribed lower center: "To Ben Weiss
From the Greek Stami"
Collection of Stephen and Mary Craven
(Plate 2)

Coney Island, 1945
Oil on masonite, 24 x 30 inches
Signed, titled, inscribed, and dated verso:
"Coney Island, Theodoros STAMOS,
146 5th N.Y.C.–U.S.A., 1945"
Collection of Nestor and Kathy Savas
(Plate 3)

The Sacrifice, 1946
Oil on masonite, 29 x 38½ inches
Signed, dated, and inscribed lower left:
"T. STAMOS '46, N.Y.C."
Signed and inscribed verso: "Theodoros
Stamos, 237 W. 26th St., N.Y.C., USA"
(Plate 5)

Nautical Warrior, 1946–47
Oil on masonite, 17¹³/₁₆ x 24⅛ inches
Signed and dated lower left:
"T. Stamos 46–47"
Titled verso: "Nautical Warrior"
(Plate 4)

Ancient Land (TAO 810), 1947
Oil on masonite, 45 x 58 inches
Signed and dated lower left: "T. Stamos '47"
Signed, titled, and dated verso: "Stamos,
ANCIENT LAND, 1947"
(Plate 7)

What the Wind Does, 1947
Oil on board, 10⅞ x 18¼ inches
Signed and dated lower left: "Stamos 1947"
Titled and signed verso: "'What the Wind
Does' Stamos #35"
(Plate 6)

Migration, 1948
Oil on masonite, 36 x 48 inches
Signed and dated lower left: "T. STAMOS. '48"
(Plate 8)

Flight of the Spectre, 1949
Oil on masonite, 29½ x 23¼ inches
Signed and dated lower left: "T. STAMOS '49"
Collection of Georgianna Stamatelos Savas
(Plate 9)

Untitled, 1950
Gouache on paper, 18 x 24 inches
Signed and dated lower left: "Stamos 1950"
(Plate 10)

Old Egypt, circa 1952
Oil on canvas, 24½ x 39½ inches
Signed lower left: "Stamos"
(Plate 11)

Delphic Shibboleth, 1959
Oil on canvas, 60 x 50 inches
Signed lower left: "STAMOS"
Signed, titled, and dated verso:
"STAMOS, DELPHIC SHIBBOLETH, 1959"
(Plate 12)

Deseret, 1959
Oil on canvas, 58 x 70 inches
Signed lower left: "Stamos"
Signed, titled, and dated verso:
"Stamos, Deseret, 1959"
(Plate 13)

Sentinel III, 1960
Oil on canvas, 56 x 52 inches
Signed lower left: "Stamos"
Signed, titled, and dated verso:
"Stamos, Sentinel III, 1960"
(Plate 14)

White Sun-Mound, 1963
Acrylic and oil on cotton, 68 x 56 inches
Titled and dated verso: "WHITE
SUN-MOUND, 1963"
(Plate 15)

Olivet Sun-Box #II, 1967
Acrylic on canvas, 48 x 70 inches
Signed, titled, and dated verso:
"Stamos, OLIVET SUN-BOX II, 1967"
(Plate 16)

Classic Yellow Sun-Box, 1968
Acrylic on canvas, 36 x 48 inches
Signed, titled, and dated verso: "Stamos,
CLASSIC YELLOW SUN-BOX, 1968"
(Plate 18)

Delphic Sun-Box #2, 1968
Acrylic on canvas, 68 x 60 inches
Titled, dated, and signed verso:
"DELPHIC SUN-BOX #2, 1968, Stamos"
(Plate 17)

Homage to Milton Avery: Sun-Box III, 1969
Acrylic on canvas, 70 x 48 inches
Titled, dated, and signed verso: "HOMAGE TO
MILTON AVERY, SUN-BOX III, 1969, STAMOS"
(Plate 19)

Infinity Field-Olympia II, 1969
Gouache on paper, 20½ x 22¼ inches
Signed, titled, and dated verso: "Stamos,
Infinity Field-Olympia II, 1969"

Transparent Green Sun-Box, 1970
Acrylic on canvas, 68 x 48 inches
(Plate 21)

Infinity Field, 1970–71
Acrylic on canvas, 25 x 68 inches
Signed, titled, and dated verso:
"STAMOS, INFINITY FIELD, 1970–1"
(Plate 20)

Infinity Field, Lefkada, 1971
Acrylic on canvas, 85 x 67 inches
Titled, dated, and signed verso:
"INFINITY FIELD, LEFKADA, 1971, Stamos"
(Plate 22)

Untitled-Infinity Field, circa 1971
Acrylic on paper, 30 x 22 inches
Signed verso: "Stamos"

Infinity Field-Lefkada Series, 1972
Acrylic on canvas, 63½ x 105 inches
Titled, dated, and signed verso: "INFINITY
FIELD, LEFKADA SERIES, 1972, t. stamos"
(Plate 23)

Infinity Field-Lefkada Series, 1973
Acrylic on canvas, 79 x 56 inches
Titled, dated, and signed verso: "INFINITY
FIELD, LEFKADA SERIES, 1973, Stamos"
(Plate 24)

Infinity Field-Knossos, 1973–74
Acrylic on canvas, 90 x 48 inches
Titled and dated verso: "INFINITY
FIELD, KNOSSOS, 1973–4"
(Plate 25)

Infinity Field-Lefkada Series #II, 1974
Acrylic on paper, 22⅜ x 30¼ inches
Signed and dated lower left: "Stamos 1974"
Inscribed verso: "come weep, and with
my blood dye your hair"

Infinity Field-Lefkada Series, 1977
Acrylic on canvas, 72⅛ x 59¾ inches
(Plate 26)

Infinity Field (HH/TS/7), 1978
Oil on canvas, 72 x 65½ inches
Signed and dated verso: "Stamos 1978"
(Plate 27)

Infinity Field, Lefkada Series #2, 1978
Watercolor and gouache on paper,
30 x 22 inches
Signed, titled, and dated verso: "Stamos,
Infinity Field, Lefkada Series, 1978"
(Plate 28)

Infinity Field, Lefkada Series #3, 1978
Watercolor and gouache on paper,
30 x 22 inches
Signed, titled, and dated verso: "Stamos,
Infinity Field, Lefkada Series #3, 1978"
(Plate 29)

Infinity Field, Lefkada Series #4, 1978
Watercolor and gouache on paper,
30 x 22 inches
Signed, titled, and dated verso: "Stamos,
'Infinity Field, Lefkada Series' #4, 1978"

Infinity Field, Lefkada Series #5, 1978
Watercolor and gouache on paper,
30 x 22 inches
Signed, titled, and dated verso: "Stamos,
'Infinity Field, Lefkada Series' #5, 1978"

Infinity Field, Lefkada Series #5, 1978
Acrylic on paper, 30½ x 22¼ inches
Titled and dated verso: "Infinity Field,
Lefkada Series #5, 1978"
(Plate 31)

Infinity Field, Lefkada Series #8, 1978
Acrylic on paper, 22¼ x 30¼ inches
Signed, titled, and dated verso: "Stamos,
Infinity Field, Lefkada Series #8, 1978"
(Plate 32)

Infinity Field, Lefkada Series #11, 1978
Watercolor and gouache on paper,
22 x 30 inches
Signed, titled, and dated verso: "Stamos,
Infinity Field, Lefkada Series, 1978"
(Plate 30)

Infinity Field-Lefkada Series, 1981
Acrylic on paper, 22½ x 30⅛ inches
Signed, titled, and dated verso: "Stamos,
Infinity Field, Lefkada Series, 1981"

Infinity Field, 1982–83
Acrylic on canvas, 60 x 50 inches
Titled, inscribed, signed, and dated
verso: "Infinity Field, for C. D. Friedrich,
Stamos, 1982–83"
(Plate 34)

*Infinity Field, Lefkada Series
(For Niko Xylouris)—Triptych,* 1982–83
Acrylic on canvas, 24 x 24 inches (each)

Left: Titled, dated, and inscribed: "'INFINITY
FIELD, LEFKADA SERIES,' 1982–3 FOR NIKO
XYLOURIS ('LAST WHITE MORNING'), #25,
62 x 61 CM"
Center: Titled, dated, signed and inscribed:
"Infinity Field, Lefkada Series/For Niko
Xylouris/Ominous Noon/Stamos 1982–3,
30 x 30, #24, 62 x 61"
Right: Titled, dated, signed, and inscribed:
"Infinity Field Lefkada Series 1982–3,
Stamos/to/Niko Xylouris, 'White Night,' #26,
62 x 61 CM"
(Plate 33)

Infinity Field-Jerusalem Series, 1983
Acrylic on canvas, 61¾ x 58 inches
Titled, dated, and signed verso: "INFINITY
FIELD, JERUSALEM SERIES, 1983, Stamos"

Infinity Field-Lefkada Series, 1983
Acrylic on paper, 30 x 22¾ inches
Titled, signed, and dated verso:
"Infinity Field, Lefkada Series, Stamos, 1983"
(Plate 36)

Infinity Field-Jerusalem Series, 1983–84
Acrylic on canvas, 56⅛ x 44⅛ inches
Titled, dated, and signed verso: "INFINITY FIELD
JERUSALEM SERIES, 1983–84, Stamos"
(Plate 35)

Infinity Field-Jerusalem Series, 1984
Acrylic on paper, 30 x 22¾ inches
Titled, signed, and dated verso: "Infinity Field,
Jerusalem Series, Stamos, 1984"
(Plate 37)

Infinity Field-Jerusalem Series (XIV), 1984
Acrylic on paper, 30 x 22 inches
Signed, titled, and dated verso: "Stamos,
Infinity Field, Jerusalem Series, XIIII, 1984"

Edge of Burning Bush (A), 1986
Acrylic on canvas, 62 x 50 inches
Signed, titled, and dated verso: "Stamos,
'EDGE OF BURNING BUSH' A, 1986"
(Plate 38)

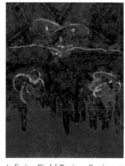

Infinity Field-Torino Series #1, 1986
Mixed media on paper, 30¼ x 21⅝ inches
Titled, signed, and dated verso: "Infinity Field
(Torino Series #1), Stamos, 1986"

Infinity Field-Torino Series #7, 1986
Acrylic on canvas, 72 x 48 inches
Signed, titled, and dated verso: "Stamos,
INFINITY FIELD-TORINO SERIES #7, 1986"
(Plate 39)

Infinity Field JS #2, 1992
Acrylic on canvas, 60 x 50 inches
Collection of Prof. Athena Lazarides Demetrios
Titled, dated, and signed verso: "'INFINITY
FIELD, J SEIRS,' #2, 1992, STAMOS"
(Plate 40)

SELECTED PUBLIC COLLECTIONS

Addison Gallery of American Art, Andover, Massachusetts

Albright-Knox Art Gallery, Buffalo, New York

Art Gallery of Ontario, Toronto, Canada

Art Students League, New York

Art Institute of Chicago, Illinois

Baltimore Museum of Art, Maryland

The Brooklyn Museum of Art, New York

Butler Institute of American Art, Youngstown, Ohio

California Palace of the Legion of Honor, San Francisco

The Chrysler Museum of Art, Norfolk, Virginia

Columbus Gallery of Fine Arts, Ohio

The Corcoran Gallery of Art, Washington, D.C.

Davis Museum and Cultural Center, Wellesley College, Massachusetts

Des Moines Art Center, Iowa

The Detroit Institute of Arts, Michigan

Fogg Art Museum, Harvard University, Cambridge, Massachusetts

Frances Lehman Loeb Art Gallery, Vassar College, Poughkeepsie, New York

Herbert F. Johnson Museum of Art, Cornell University, Ithaca, New York

High Museum of Art, Atlanta, Georgia

Hirshhorn Museum and Sculpture Garden, Smithsonian Institution, Washington, D.C.

Jane Voorhees Zimmerli Art Museum, Rutgers University, New Brunswick, New Jersey

Kresge Art Museum, Michigan State University, East Lansing

La Jolla Museum of Art, California

Los Angeles County Museum of Art, Los Angeles, California

Massachusetts Institute of Technology, Cambridge

McNay Art Museum, San Antonio, Texas

The Metropolitan Museum of Art, New York

Mint Museum of Art, Charlotte, North Carolina

Minneapolis Institute of Arts, Minnesota

The Montclair Art Museum, New Jersey

Munson-Williams-Proctor Institute, Utica, New York

Museo d'Arte Moderno, Rio de Janeiro, Brazil

The Museum of Modern Art, New York

National Gallery and Alexandros Soutzos Museum, Athens, Greece

National Gallery of Art, Washington, D.C.

New Jersey State Museum, Trenton

Philadelphia Museum of Art, Pennsylvania

The Phillips Collection, Washington, D.C.

Rose Art Museum, Brandeis University, Waltham, Massachusetts

Sheldon Memorial Art Gallery, University of Nebraska, Lincoln

Smithsonian American Art Museum, Washington, D.C.

Solomon R. Guggenheim Museum, New York

Syracuse University Art Gallery, New York

Tel Aviv Museum, Israel

Virginia Museum of Art, Richmond, Virginia

Wadsworth Atheneum, Hartford, Connecticut

Walker Art Center, Minneapolis, Minnesota

Whitney Museum of American Art, New York

Wilhelm-Hack-Museum, Ludwigshafen, Germany

Right: Theodoros Stamos in his East 83rd Street studio, circa 1979–80. Photo by Diran Deckmejian